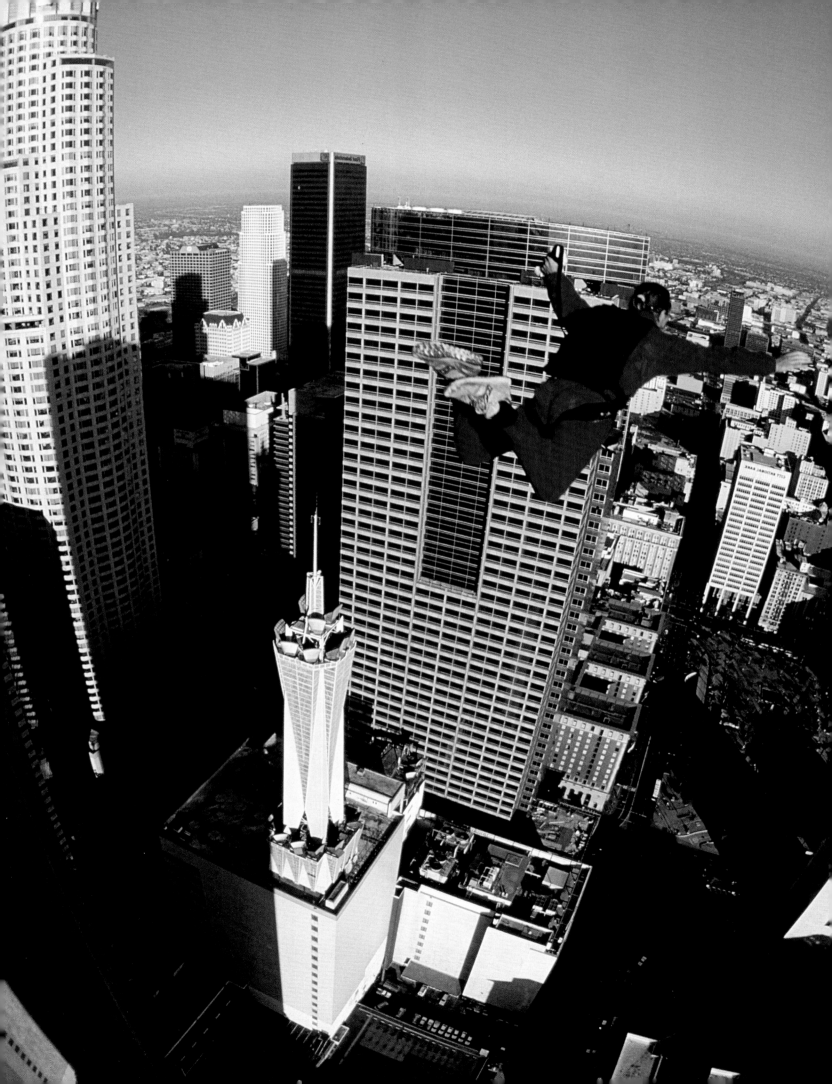

MAXIM'S BOOK OF
BIG
PICTURES

MAXIM'S BOOK OF
BIG PICTURES
HOT BABES, STRANGE FREAKS AND BAD, BAD ACCIDENTS

BY THE EDITORS OF
MAXIM

MAXIM
B O O K S
DDM Press

DDM Press 1040 Avenue of the Americas New York New York 10018
212-302-2626 http://www.maximonline.com

For more information on Maxim Books, call 1-877-212-1937

MAXIM'S BOOK OF
BIG PICTURES:
HOT BABES, STRANGE FREAKS
AND BAD, BAD ACCIDENTS

Portions of this text have been adapted from *Maxim* and *Stuff* magazines.

Maxim and *Stuff* are registered trademarks of Dennis Publishing, Inc.

ISBN 0-9675723-2-0
Printed in the United States of America on recycled paper.

MAXIM'S BOOK OF
BIG
PICTURES

HOT BABES, STRANGE FREAKS AND BAD, BAD ACCIDENTS

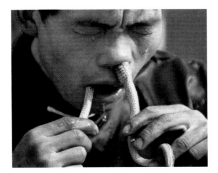

Senior Writer	Jon Seder
Art Director	Cindy Williamson
Photo Editor	Loretta Black
Production Editor	Rob Simpson
Associate Photo Editors	Jaemin Paik, Brian Inatsuka
Associate Editors	Dawn Yanek, Sky Shineman
Writers	Charles Coxe, John Walsh, Bryan Walsh, Alex Strauss, Ky Henderson

DDM Press

Chairman	Felix Dennis
President	Stephen Colvin
Chief Financial Officer	Paul Fish
Publisher	Steven Kotok
Group Creative Director	Keith Blanchard
Production Manager	Lou Terracciano
Direct Marketing Manager	Joanna Molfetta
Directors	Robert G. Bartner, Peter Godfrey

BAD, BAD ACCIDENTS Photo Credits

p. 18-19 (series of MiG exploding): Ron Richards, Liaison; **p. 20-21** (bay filled with whale blood): Adam Woolfitt, National Geographic; **p. 22-23** (surfers on monster waves): Jamie Squire, Allsport; Bruce Ellis, Allsport; **p. 24-25** (Kobe, Japan earthquake): Naoto Hosaka, Liaison; Noboru Hashimoto, Corbis-Sygma; **p. 26-27** (rodeo clown attacked by horse): Brian Bahr, Allsport (x2); Ferry, Liaison; **p. 30-31** (bull chasing man): Bruno Bade, Allsport (x4); **p. 33** (german grand prix car flipping over): Archive; **p. 36-37** (lion jumping zebra): Gerard Lacz, Animals Animals; Tom Brakefield, The Stock Market (inset); **p. 41** (seahorse giving birth): Kuiter, Animals Animals; **p. 42-43** (George Foreman getting punched by Tommy Morrison): Marc Morrison, Allsport; **p. 44-45** (man on horse diving into ground): Popperfoto, Archive; **p. 46** (circus train wreck): The Ledger, Liaison; **p. 47** (soccer player breaking leg): The Times, Rex Photo; **p. 48-49** (speedboat hitting onlookers): Pierre Paul Poulin, Liaison (x2); **p. 50-51** (truck sinking into mud): Xavier Joussain, Liaison; **p. 52-53** (mushroom cloud): Stockman, International Stock; **p. 56-57** (Amtrak train over bridge): Devon Ravin, Corbis-Sygma; **p. 58** (BASE jumper going off skyscraper): Tom Sanders, Adventure Photo; **p. 60-61** (man jumping chasm): Eric Perlman, Adventure Photo; **p. 64-65** (jaguar eating caiman): Loren McIntyre, National Geographic; **p. 67** (moose with bloody antlers): Michael Quinton, National Geographic; **p. 68-69** (plane crashing into truck): Robert Madden, National Geographic; **p. 72** (going over waterfall in kayak): Oliver Lewis, Adventure Photo; **p. 73** (firemen at gushing well): S. Compoint, Corbis-Sygma; **p. 74-75** (lightning strikes): Warren Faidley, Weatherstock (x2); **p. 76** (skeleton on Everest): Greg Child, Adventure Photo; **p. 78-79** (camel race): Jodi Cobb, National Geographic; **p. 85** (men jumping off waterfall in Venezuela): Ken Fisher, Stone; **p. 86-87** (decapitation of Chinese revolutionary): Hulton Getty, Liaison; **p. 88-89** (waterspout with lightning): F.K. Smith; **p. 92** (erupting volcano in Hawaii): Robert Madden, National Geographic; **p. 96-97** (animals having sex) *top* (l to r): Ted Levin, Animals Animals, Chris Johns, National Geographic; J. Mitchell, Animals Animals; *middle* (l to r): Pologne/M Kozlowski, Liaison; Zig Leszczynski, Animals Animals; George Bernard, Animals Animals; *bottom* (l to r): Stefan Meyers, Animals Animals; Rick Edwards, Animals Animals; Patti Murphy, Animals Animals; **p. 98** (speedboat collision): Rex Photo; **p. 99** (men descending into cave): Stephen Alvarez, Adventure Photo; **p. 100-101** (upside-down race car crash): Allsport; **p. 103** (tracer bullets at night): Reza Deghati, National Geographic; **p. 104-105** (race horse collision): O. Louis Mazzatenta, National Geographic; **p. 106-107** (light through clouds over island): Gordon Gahan, National Geographic; **p. 109** (bicycle accident): Richard Martin, Allsport; **p. 110-111** (camels treking across desert); Chris Johns, National Geographic; **p. 112** (bull impaling man): Reuters/El Tiempo, Archive; **p. 115** (man sandboarding): SportsChrome; **p. 116-117** (funnel cloud over mountain): Ronald Warfield, Weatherstock; **p. 118-119** (tightrope walking over chasm): Greg Epperson, Adventure Photo; **p. 122-123** (L.A. riots fire): Liaison; **p. 124-125** (house lost in sinkhole): Bill Losh, FPG; **p. 130-131** (street filled with dead pigs): Gert Eggenberger, AP Photo.

SPECIAL THANKS TO
THE READERS OF MAXIM
FOR THEIR GOOD HUMOR AND SUPPORT.

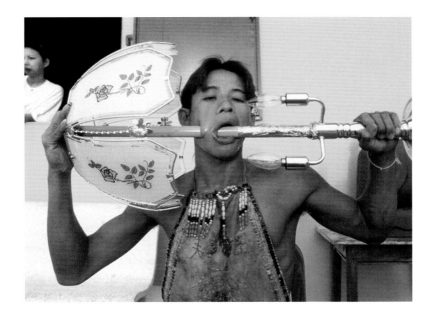

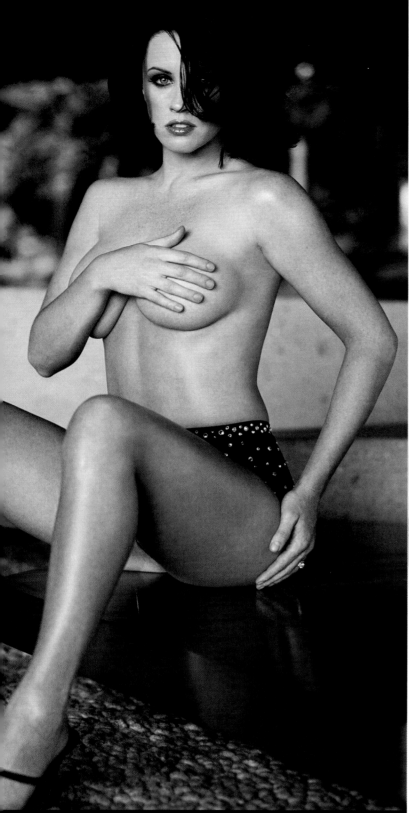

HOT BABES

CONTENTS

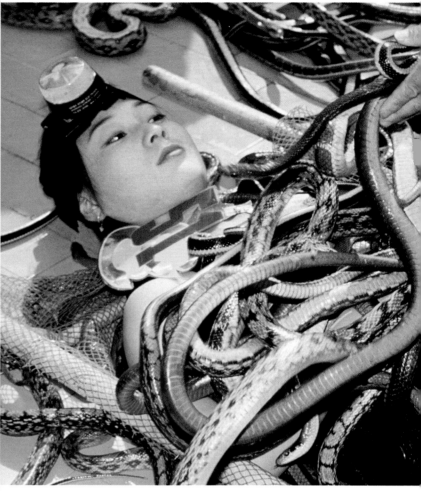

STRANGE FREAKS

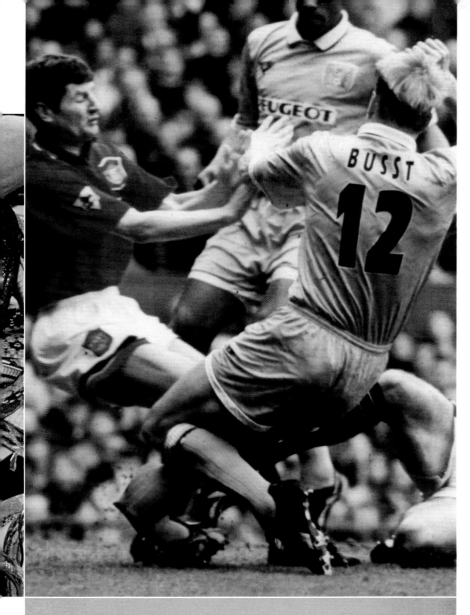

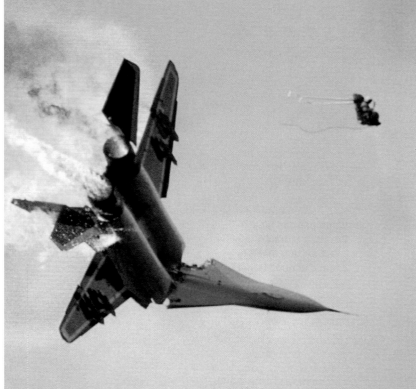

BAD, BAD ACCIDENTS

CONSIDER THIS:

The first photos taken of Heidi Klum in America (p. 59, 114). A man's recently guillotined fingers neatly placed above the bloody stumps (p. 66). A family of two-toed people from a two-toed tribe (p. 108). A man pushing a shopping cart through the raging fires of the L.A. riots (p. 122). A matador receiving a surprise proctology exam from a bull (p. 112).

What makes a 'Big Picture?' Like the gruesome car accident, hot babe or deranged freak we all respectfully gawk at on the street, it's something you just can't look away from. Maybe you grab your friends and make them look, too...or maybe you just dream about it. But one thing's for sure: You can't just walk by and forget it.

As Publisher of Maxim Books, I'm often asked: 'Where did you get these photos?' And, 'Just what kind of a sick person are you?' And, of course, 'When are you going to get a real job?' Allow me to address just the exact kind of sick people we are here at *Maxim* and how we ended up with the most mesmerizing collection of photos known to man.

It all started when I sent an e-mail around the office soliciting ideas for a worthy follow-up to our first book, the very successful *WOMEN: Maxim's Unauthorized Guide*. The *Maxim* editors submitted countless suggestions that involved flying them to exotic locales with a bevy of beautiful models and getting drunk. It wasn't precisely clear how a book would emerge from this process, but, having no original ideas of my own, I was open to anything.

But *Maxim* Magazine Art Director David Hilton, the one lucky S.O.B. here who actually *does* fly all over the world with our cover girls (and always returns looking exhausted and hung over) spoiled it for the rest of the class with the following suggestion:

> *"A book of 'big pictures.'* Maxim *runs a spread every issue called* The Big Picture *(e.g., plane hitting a guy's truck as he runs away, skewer through guy's face, amazing surfer shot, etc. Some are amazing and others just grotesque. Maybe some mileage in putting them all together in a book?"*

Instantly, I knew I had my book. No words to edit, no annoying authors, no pissy editors [editors' note: take this part out], just photos that would scare the crap out of your grandmother. So I went ahead and made that book—in fact, Dave's suggestions are on pages 68, 70, and 22, respectively.

I'm not going to lie to you: It was a blast making this book. But it wasn't always easy. How do you choose between a slick, futuristic photo of a bodacious Jenny McCarthy and volleyball goddess Gabrielle Reese's perfect bod as she surveys a perfect beach? (Okay, that one was easy—we chose both, on pages 32 and 102.) What makes a great car crash? (Check out our selections on pages 33 and 100 and see if you agree.) How many animal sex shots can dance on a two-page spread? (The surprising answer is nine: See pages 96 & 97.)

Several alcohol-fueled, late-night photo-selection sessions later, we'd reviewed over 5,000 photographs and made our bleary-eyed choices. You're about to experience over 100 pages of the biggest, wildest, gnarliest pictures we've ever seen—and believe me, we've seen a lot. We humbly present *MAXIM'S BOOK OF BIG PICTURES: Hot Babes, Strange Freaks and Bad, Bad Accidents.*

And for God's sake, don't leave this where Grandma will find it.

STEVEN KOTOK
Publisher, Maxim Books

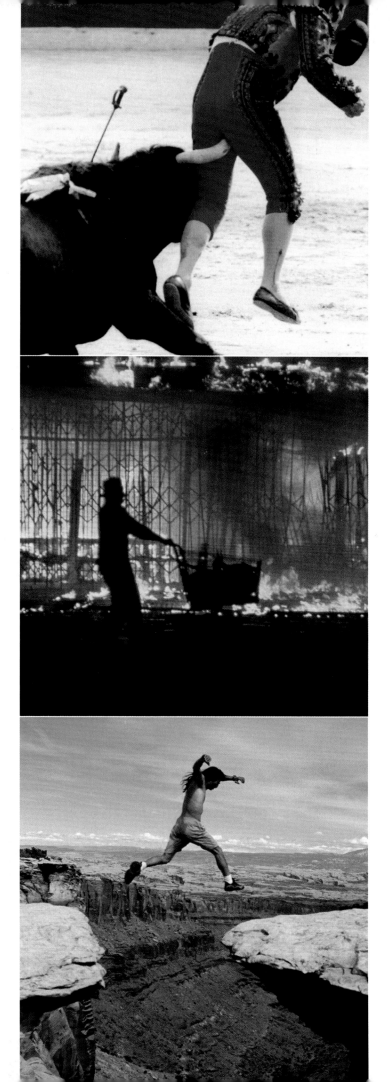

MAXIM'S BOOK OF
BIG
PICTURES
HOT BABES, STRANGE FREAKS
AND BAD, BAD ACCIDENTS

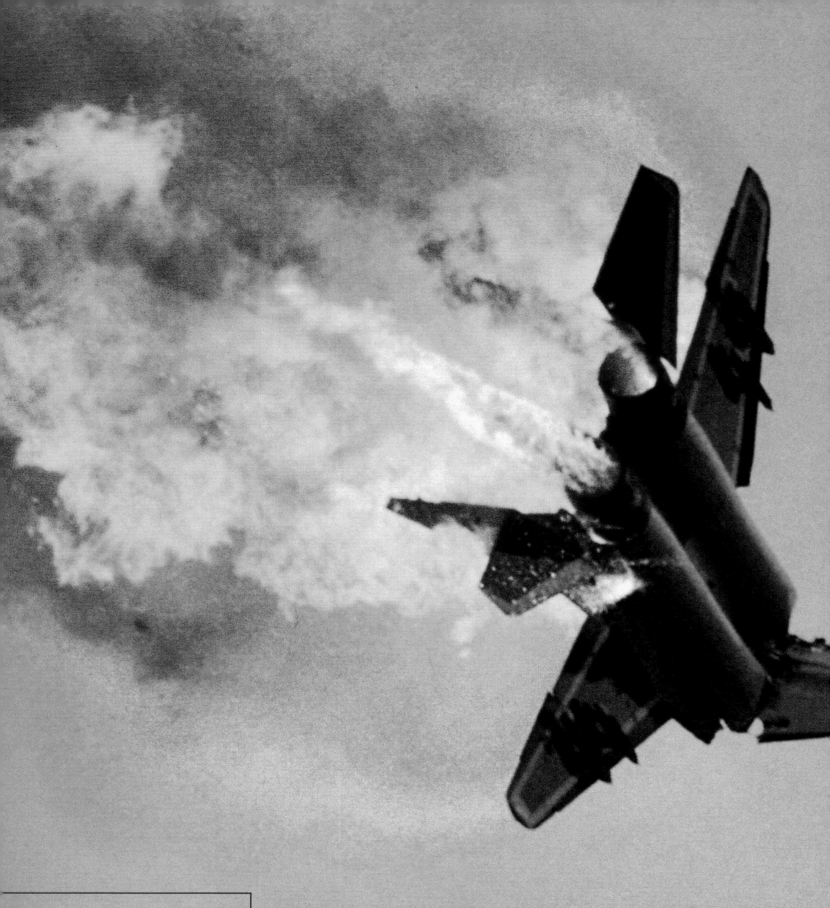

"De-plane! De-plane!"

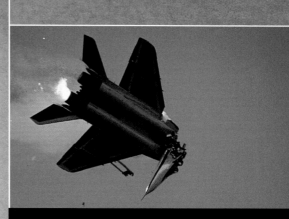

"Please feel free..."

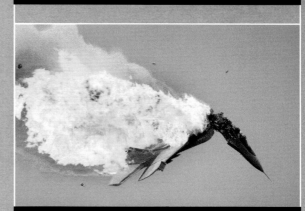

"...to move about the cabin."

EJECTILE DYSFUNCTION

A Russian pilot shows off the superior tactical skill that's the heart and soul of his country's mighty aerospace industry.

At 1993's International Air Tattoo (don't ask) in Fairford, England, spectators who came for an air show were treated to a demolition derby, a fireworks display, and even a street fight. Eight hundred feet above the crowd, civilian pilots Sergei Tresvyatsky and Alexander Beschastnov, in matching MiG-29 fighters, were flying in tight formation during the Royal Air Force's 75th anniversary celebration. Then Beschastnov pulled up prematurely, cutting across Tresvyatsky's path and slicing the other pilot's plane nearly in half with his left wing. Tresvyatsky immediately activated the 14,000-pound-thrust booster rocket on his ejection seat and was propelled up, up and away just seconds before his cockpit exploded in flames. Beschastnov, who also ejected without injury, paid the price after parachuting to safety. A helicopter rescue crew watched as the two uninjured pilots went at each other on the ground. The dustup sent Beschastnov to a local military hospital, where he was treated for a broken jaw and busted lip.

CRIMSON TIDE

Never-before-seen footage from
Free Willy 4: The Reckoning.

Welcome to the foggy isle of Tindholmur, one of the North Atlantic's Faroe Islands. Floating between Iceland, Norway, and Scotland, these craggy map specks evoke images of mist-shrouded castles, Viking expeditions, and Led Zeppelin album cover art. Their inhabitants have subsisted largely on whale meat and oil for literally thousands of years, and the culture draws much of its identity from this pursuit. Squeamish and environmentally minded *Maxim* readers (both of you) can take comfort in knowing that: a) in recent years, veterinarians have monitored these whale hunts to ensure that humane methods of killing are observed, and b) pilot whales, like the ones spilling their guts here, are not an endangered species. Not yet, anyway. If this doesn't make you feel better, go on and blubber your heart out.

"I wonder if anyone knows I'm pissing..."

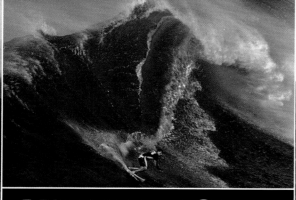

SURFIN' DOA

Professional surfer Bryce Ellis fails to remember his sport's only rules—stay on the board, and try not to look stupid.

Occasionally, we find ourselves drawn to photos of an athlete at the top of his game, transforming his sport into a transcendent work of art...like the surfer above. Most of the time, though, we prefer seeing athletes wreck dramatically, because a) crashes are just more fun, as any NASCAR fan knows, and b) it lets us unathletic schlubs feel superior for a little while. This surfer, about to see how much of the Pacific he can chug, is Bryce Ellis, off the coast of Haleiwa, Hawaii. Yes, the landing and the violent sand-up-the-ass spin cycle he's about to undergo will be excruciatingly painful, but don't forget that he's probably used words like "tubular" and "bodacious" before, and therefore wholly deserves this fate.

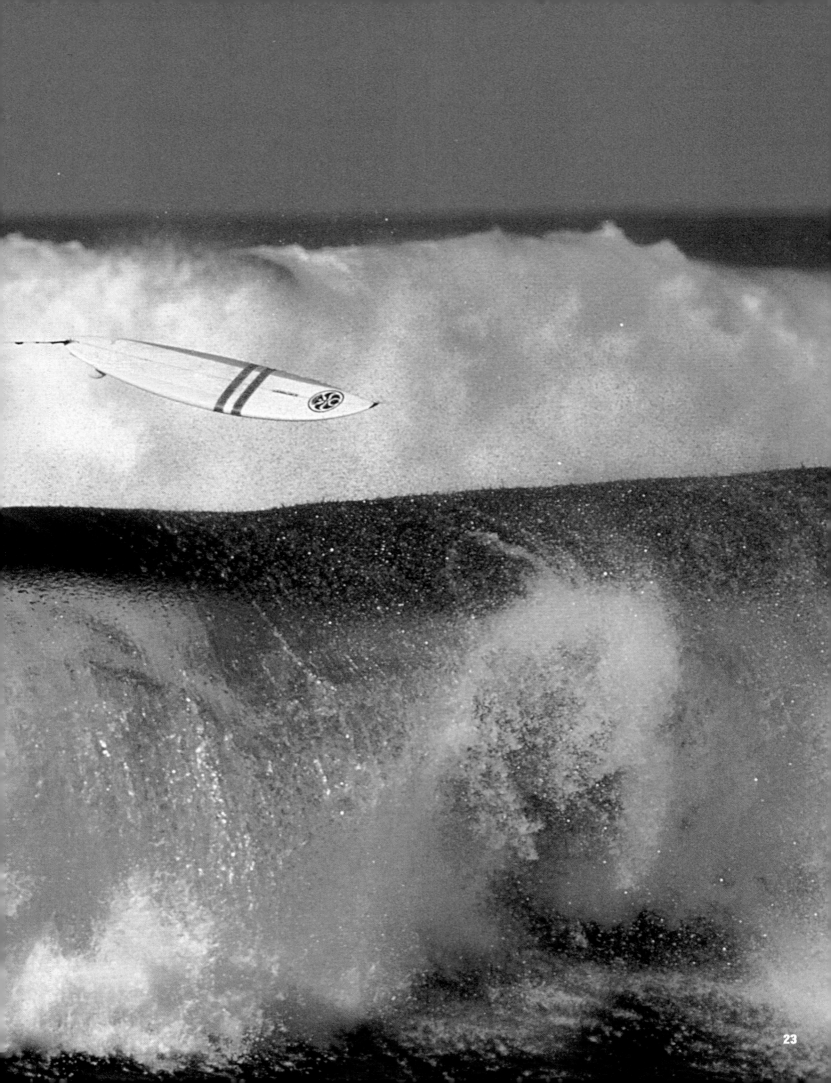

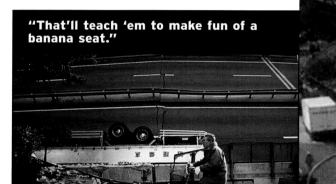

"That'll teach 'em to make fun of a banana seat."

SHAKE 'N' BREAK

Japan hadn't endured this much carnage since giant, radioactive monsters assaulted Tokyo.

By now you've no doubt forgotten the earthquake that ravaged Kobe, Japan on January 17, 1995, which killed thousands, cost hundreds of billions and left the city's infrastructure in shambles. In case you ever get a hankering to feel puny and insignificant, check out the bloody aftermath of this unholy hiccup.

Richter scale rating: 7.2
People killed: 6,300-plus
People injured: 30,000
People left homeless: 307,000
Buildings damaged: 190,000
Number of reservoirs dry within 24 hours of the quake: 86
Percent of the population in Kobe that lost its water supply: 90
Number of acres burned by subsequent fires: 300
Length of the Hanshin Expressway section that rolled over: 1,650 feet
Estimated total damage: $200 billion

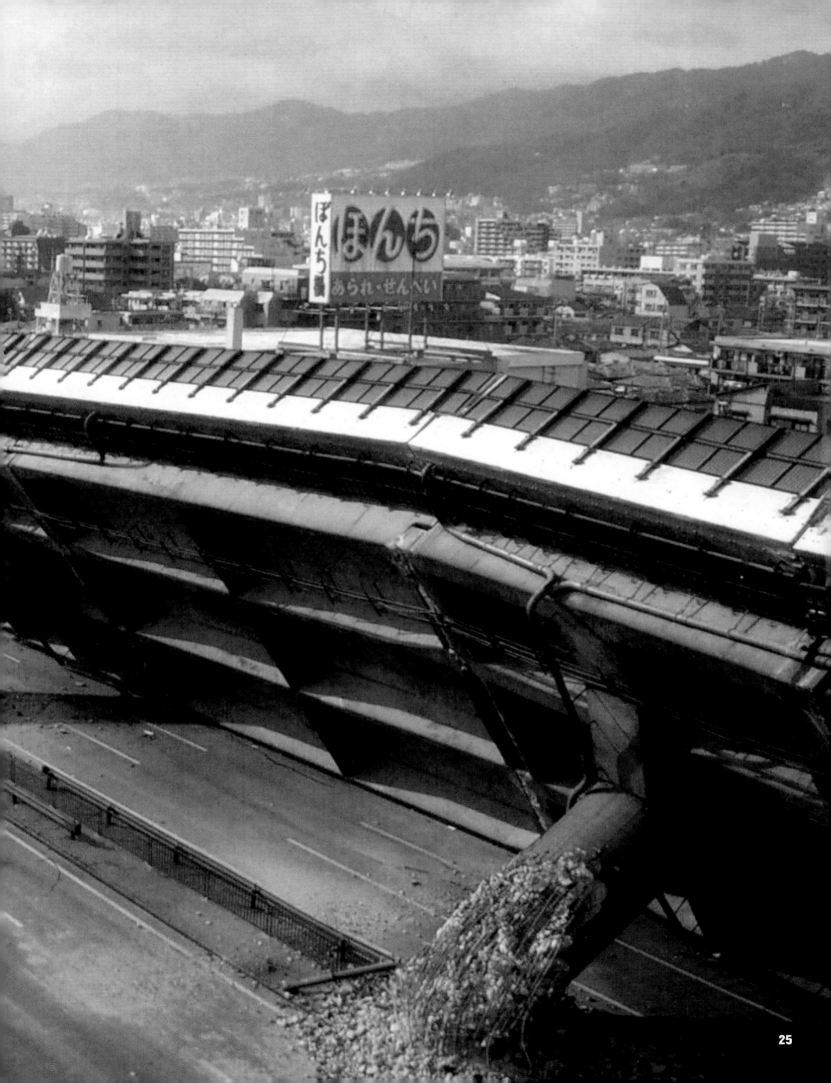

RODEO CLOWNS

There's a place Americans go to pay for the privilege of getting trampled, shoved, stampeded, battered and impaled. And it ain't even the New York subway.

One summer day in 1997, Jim Hubbard went to the Cheyenne Frontier Days in Wyoming and brought home some interesting souvenirs: a broken foot, a broken leg, a broken arm, and a side of badly bruised ribs. In an act of brain-dead bravado, the mild-mannered radiologist decided at the last moment to compete in the annual rodeo spectacular's most popular event: the wild-horse race. "I never even made it onto the #&*@%@**%#&!!! horse," Hubbard later admitted. "I just got the crap kicked out of me." Too bad he wasn't in a competition for stating the obvious. The weeklong lassopalooza that bills itself as the "Daddy of 'em All" also features the usual rodeo events—you know, bucking-bronco riding, steer and calf roping, and sheep embuggering (the last one we're not 100 percent sure about). But the biggest crowds flock to see the amateurs compete—an instinct we applaud. After all, who wants to see a bunch of graceful cowpokes making it look easy when you can watch local goons tanked on cheap beer getting dragged feet-first through the manure? That, my friend, is rodeo.

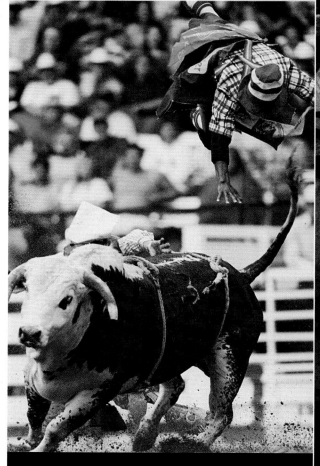

"Look, everybody! I'm a DC-10!"

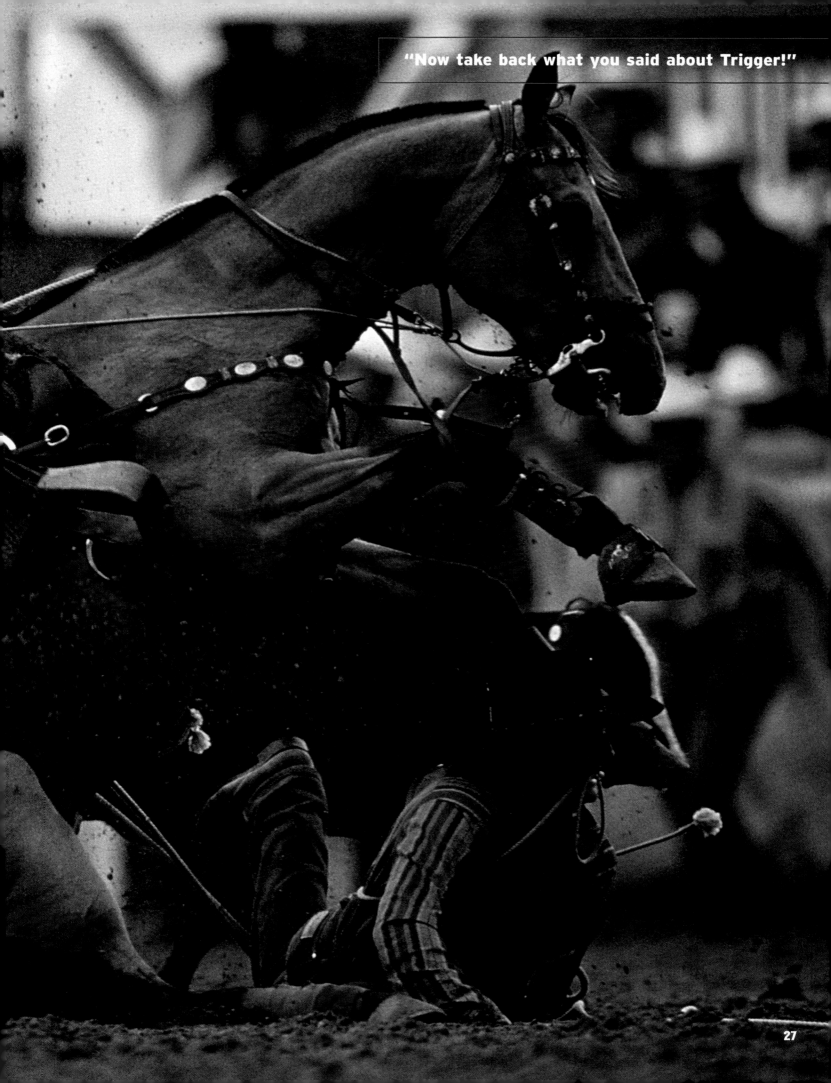

"Now take back what you said about Trigger!"

DOUBLE HEADER

Some days part of you feels like going for a run, but another part just wants to stay in bed.

So you beat the odds (roughly 80,000 to one) and weren't born a Siamese twin? Good for you. But don't head out for a celebratory ride on your single-seater bicycle just yet: Some conjoined twins can literally pop up in an otherwise normal person years after birth. Earlier this century, a nine-year-old boy developed a tumor in his abdomen that turned out to be—AAAAAAAGH!!!— the growing body of a parasitic twin. (The stowaway eventually grew too large for the child to contain it, and both died.) But in most cases of conjoined—or Siamese—twins, the two fetuses develop at the same rate. How it happens: The developing embryo begins to split into identical twins but fails to complete the process. Some twins, like the ones in this vintage X-ray photo, share entire torsos: one heart, one stomach, one ball each, etc. Others are joined at the pelvis, chest, or—toughest on smoking/nonsmoking pairs—the head. Depending on which organs are shared, many conjoined twins can now be successfully separated. And hey, relax: That's probably just a cyst on your back. Nothing to worry about.

TWO TIMES
A LADY

You can't choose your family, but at least you can move thousands of miles away from them. Can't you?

Masha and Dasha Krivoshlyapov are close...real close. At 49, the Russian sisters are thought to be the world's oldest living Siamese twins. Joined at the trunk, the sisters share two legs but each has her own pair of arms. They've spent their lives trying to convince others that they are two distinct people, not "a girl with two heads," as the head on the left puts it. Apparently there are differences: Masha claims she's "less romantic and more realistic" than her sister. That's helpful...not that you could date just the one. Sadly, they used to fight over their respective addictions: Masha smoked and Dasha drank, and each suffered the health effects of both habits. But with the aid of physicians, they simultaneously gave up their vices. Forgive us for saying so, but if we were in their overoccupied shoes, we'd have drastically *increased* our consumption of both substances.

The slap fights are unbelievable...

29

Despite couples' counseling, their public bickering only intensified

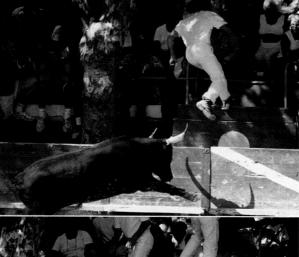

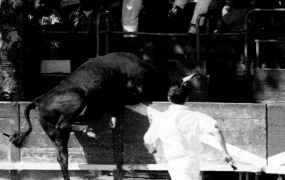

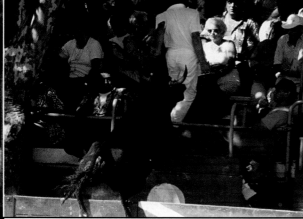

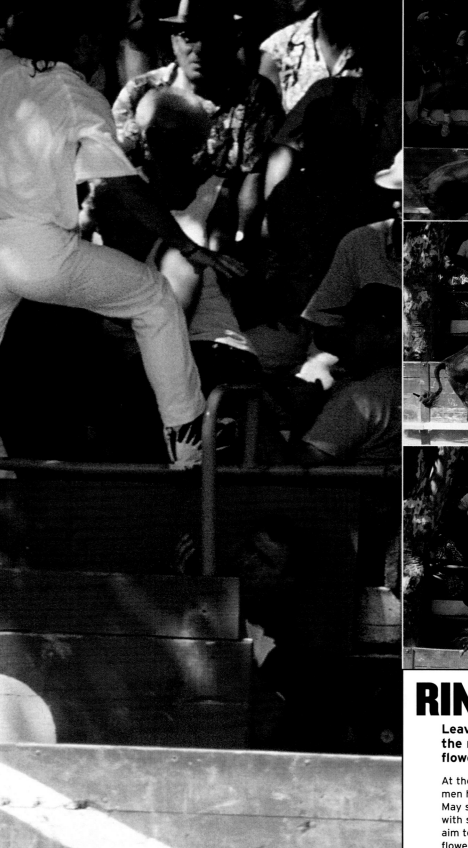

RING TOSS

Leave it to the French to pollute one of the manliest sports ever with ribbons, flowers and tassels.

At the Course Camarguaise in southern France, men have stepped into the ring with bulls every May since the 15th century. They're armed not with swords, but with finger hooks, and they don't aim to kill the bulls, but to swipe little cloth flowers off their horns. Isn't that sweet? Hmmm, stepping unarmed into a ring with angry, psychotic beasts armed and ready to pound you into the turf—sounds remarkably like France's strategy during every war they've ever fought. But enough of that. The basic idea here is that a tasseled rosette (i.e., a rose made of ribbons) is attached to the bull's horn and prizes are awarded to the daredevil who succeeds in removing it. A "course" consists of six bulls, and each competition lasts 15 minutes. And we'd like to reiterate: No animals are killed. It's not so much bullfighting as bull-annoying. Barbaric sons-of-bitches.

JENNY, JENNY

McCarthyism is back.

Name: Jenny McCarthy
Date of Birth: 11/1/72
Hometown: Chicago, Illinois
Height: 5'6"

#1 claim to fame: All-around babe celebrity whose incarnations include MTV game show hostess, *Playboy* model, and actress.

Quote: "I've had more than one guy pull down his pants and ask me to sign his ass."

Astrological profile: "I'm a typical Scorpio. That means I'm a businesswoman in public and a total slut in the bedroom."

Perfect pickup line: "You don't need a pickup line. Just glance at a woman from across the room. Glance—don't stare."

On blonde jokes: "I tell them now! I've been making fun of blondes. 'Look at that bimbo. Who does she think she is, Jenny McCarthy?'"

PRIX-BOARDING

An unidentified Grand Prix pilot—er, driver—spills his Coolatta.

Most of us will never experience the sheer visceral thrill of strapping ourselves into a sleek rocket of metal and rubber, and racing around a slinky European track at more than 200 mph. On the other hand, crap like this never happens to your AMC Pacer. Taken at the German Grand Prix in 1959, this picture shows what happens when you drive with the emergency brake on in one of the old Formula One race cars, which had all the safety features of a third-world cruise missile. At the very same race the year before, champion British F1 driver Peter Collins had been thrown out of his cockpit when his car hit a bank, killing him and, perhaps even worse, busting up a perfectly nice Ferrari. Nobody seems to have a record of what happened to this unlucky driver, but it's a good bet he didn't become a driving instructor.

FLEX TIME

Last time we saw a woman with her crotch poised this high above her head, we were watching a biker movie with your mom in it.

Mongolian superconqueror Genghis Khan was really no different than any other war-crazed autocrat: After a good day's pillaging and head-splitting, he liked to kick back and watch acrobats and animals performing stunts. Thus was born the Mongolian Circus—which has been around now for more than 700 years (some performers have changed)—famous for its ensemble of contortionists. These quasi-human rubber bands must undergo six to seven years of intense training before they are deemed ready to ooze around in public. Their art supposedly emulates the movements of the gods...which tempts us to ask: What kind of bush-league gods would move around like giant walking pretzels, anyhow?

"Could someone reach in and grab my car keys?"

POKER FACE

It's amazing how ugly some people will make themselves in the name of beauty.

Authorities believe ornamental lip plugs like the one this Makonde woman sports cause tooth decay and cancer—not to mention big ugly holes in the face. Around the non-Western world, women often have their entire bodies scarred in order to appear more attractive to men. From the time they hit puberty, female members of certain tribes in East Africa have small cuts rubbed with charcoal to produce raised scars. Men believe that these women have greater sex drives—meaning they'll bear them more children—and think the scars on their backs will heighten sexual pleasure. After a woman has her first child, she traditionally has one final set of tattoos done. However, if her husband won't pay for them, the woman often finds another lover who will. Hmm...maybe our cultural differences aren't that great after all—we do the same thing with jewelry.

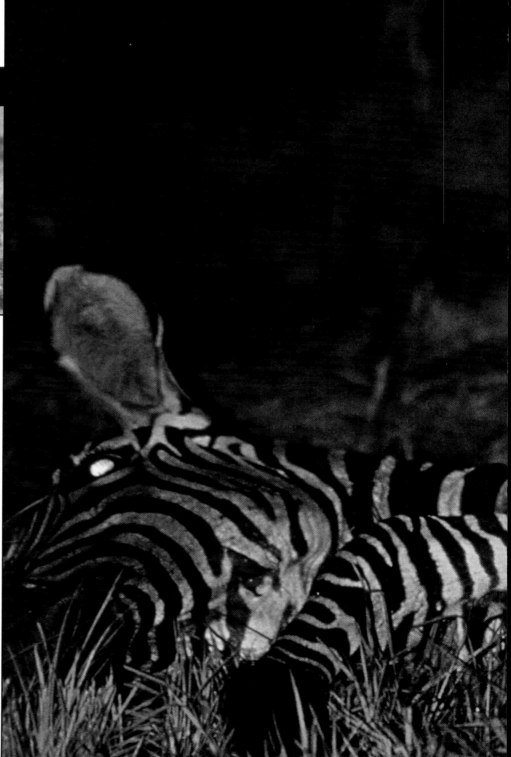

"OK, wrap the rest to go."

Up next: *Terror at the Petting Zoo*

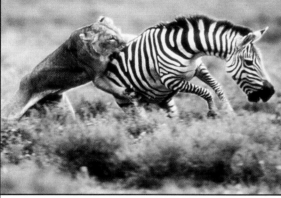

BLACK AND WHITE AND RED ALL OVER

When you've spent a hard day loafing around on the savannah, nothing truly satisfies like a fresh, steaming, bloody zebra carcass.

King of the jungle? Damn straight. Life's a gas if you're a male lion. Simply survive to adulthood and your time on earth becomes an endless happy cycle of sleeping, eating, foreplay-free humping, and great, big catnaps. Too tired to bother chasing uncooperative dinners? Just kick back and let your woman bring home the bacon—tasty treats like gazelle, warthog, antelope, impala, wildebeest, giraffe, and buffalo (wings and all). If you are a typical adult male lion, you weigh about 450 pounds and eat approximately 50 to 60 pounds of meat per week. Forget king of the *jungle*—that sounds a lot like Elvis.

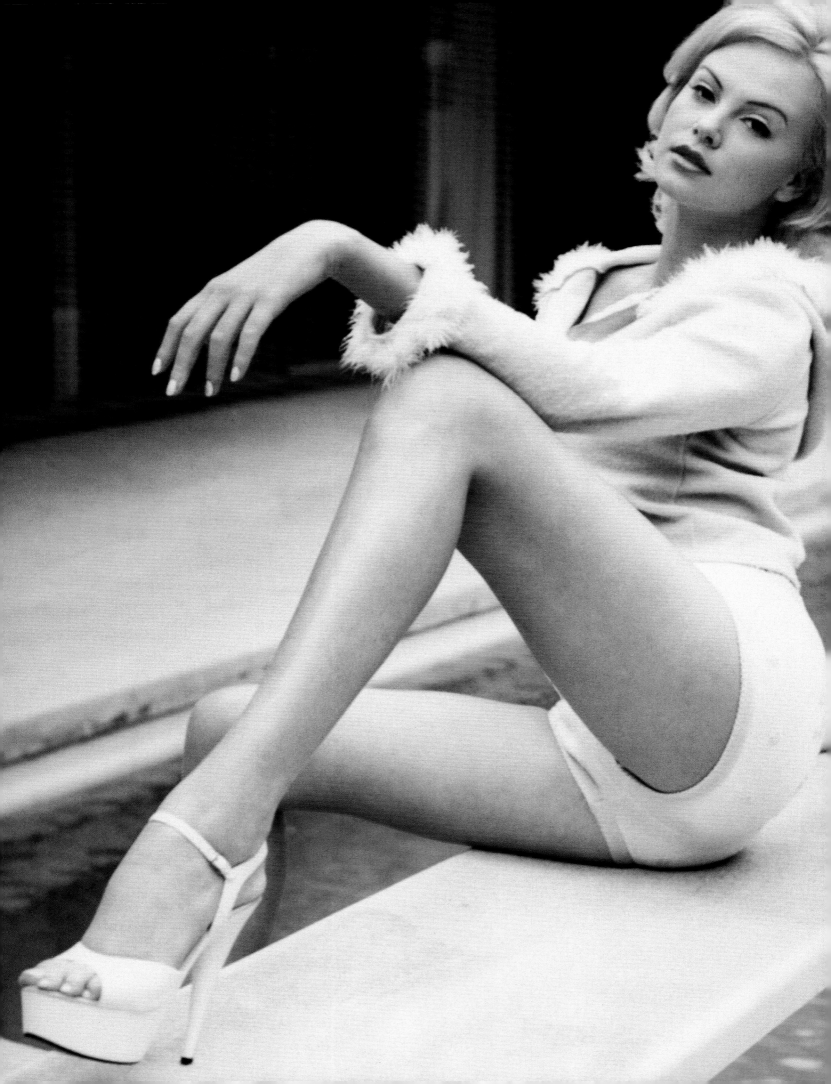

CHARLIZE ANGEL

Sometimes one glance at the poolside scenery is all it takes to make your head swim.

Name: Charlize Theron
Date of Birth: 8/7/75
Hometown: Benoni, South Africa (currently resides in Los Angeles, California)
Height: 5'9"

Quote (On being narrowly beaten out by Elizabeth Berkley for the lead role in the farcically bad *Showgirls*): "It was like I had some guardian angel."

#1 claim to fame: Lighting the screen on fire in films such as *Reindeer Games*, *Celebrity*, and *The Cider House Rules*.

Most profitable hissy fit: Charlize's big break occurred in 1994 when a talent agent witnessed her angry confrontation with a bank teller. Awed by her dramatic flair, the agent soon had her signed.

A Charlize appearance you don't want to miss: Her pictorial in the May 1999 issue of *Playboy*.

How the *New York Times* characterized her debut film performance in *2 Days in the Valley*: "Spectacularly sleazy."

SNAKES ALIVE!

Qian Linping (pictured) and her roommate set a Guinness World Record by living for 12 days with 888 snakes—most of them deadly cobras.

Amazingly, 100 women from all over China actually competed for this honor. When the snakes were first piled into the 30-square-meter glass room, all hell broke loose, and the cobras began to fight one another with such ferocity that by the end of the first night, 150 of the snakes were dead. Each day before breakfast, the girls gathered up all the dead snakes from the night before and dumped them out through a hole high in the wall, then took in new live snakes to replace them. Qian was bitten three separate times by cobras during the ordeal, but lived to receive the amazing reward of seeing her name in print. Other people collect stamps....

MALE CARRIER

The key to sea horse power: Dad's got 200 horses under the hood.

What's wrong with this picture? Nothing—it simply shows a male sea horse in labor. That's right, in the gender-bending world of the sea horse, it's the *male* who gets pregnant, carries the embryos around in a pouch, and gives birth to the young 'uns, while the females busy themselves with belching, trunk packing, and lawn-mower repair. Here's how it works. Like you, the male sea horse has a pouch (a marsupium); unlike you, his is useful for something. The female sea horse lays her eggs inside of it, and the male fertilizes them and totes them around for about three weeks. At the end of the pregnancy, he farts out 100 to 250 itty-bitty seahorses, and almost immediately "becomes pregnant" again. Insert your own "horsing around" joke here.

SMASH MOUTH

At the height of his 15 minutes of fame, Tommy Morrison hit George Foreman so hard, the man's sweat glands exploded.

Still looking for proof that God exists? Check out the halo forming around the gleaming head of 44-year-old comeback kid George Foreman as 24-year-old upstart Tommy Morrison lands a fist on his snotlocker in a June 7, 1993, Las Vegas heavyweight bout. You may ask: *Why should God be on Big George's side?* Well, for one thing, the Olympic gold medalist and former world heavyweight champ preaches the Gospel three times a week in Houston. *But he lost this Morrison fight in a 12-round decision*, you protest. Look, ya damn atheist, the Lord works in mysterious ways. One year later, the world's most congenial muffler salesman knocked out 26-year-old Michael Moorer in the 10th round to win the not-very-prestigious-but-so-what WBO heavyweight title. Satisfied?

TUMBLE STEED

At the Grand National Steeplechase, horses learn how to fly, then quickly forget.

The horse's life ain't easy. Yes, chicks dig them, and they rarely have to exaggerate the size of their penises. But would you want to spend your professional life jumping hurdles with a whip-wielding dwarf on your back? Nowhere is the horse's shitty lot more apparent than at Britain's Grand National Steeplechase, for years the equestrian equivalent of Hamburger Hill. Every year, 40 horses run the four-and-a-half-mile grass course, which includes dozens of obstacles of varying equine-killing ability. The worst of the lot is Beecher's Brook, as seen in this photo: A 4'10" fence with a deep ditch on its other side that regularly turns horses into tumbling sacks of shattered bones. So deadly is the Grand National that until the course was finally softened up in the '80s, one out of every four equine entrants wound up grazing in the Great Pasture in the Sky before race's end.

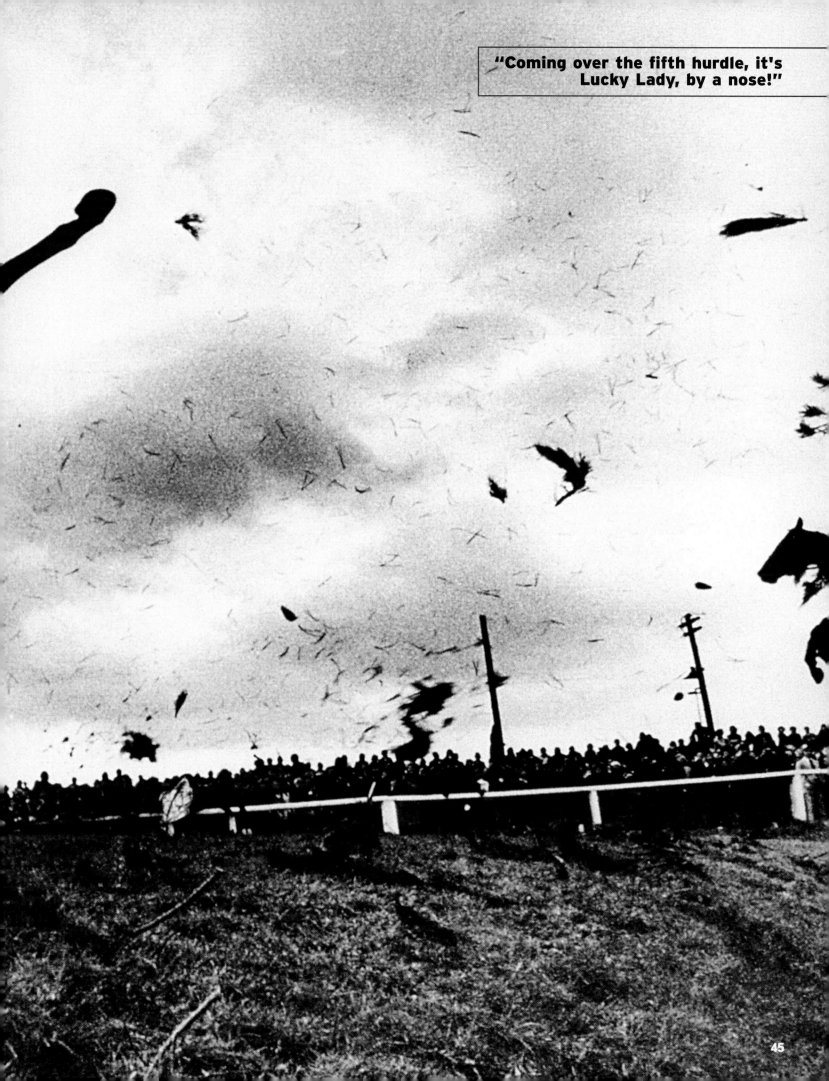

"Coming over the fifth hurdle, it's Lucky Lady, by a nose!"

"I told you dipshits not to let the monkey drive."

HAUL OUT THE CLOWNS

What happens when a circus train derails? The citizens of the small Florida town of Lakeland will never forget.

When this Ringling Bros. and Barnum & Bailey Circus train derailed on its way to Orlando, Florida on January 13, 1994, an improbable 50,000 clowns poured out, and proceeded to wreak havoc among the citizens of nearby Lakeland with bongo bats, balloon animals, and squirting flowers, leaving them helpless with laughter. Bears, lions, and elephants roamed the streets, causing little children to squeal with delight and clap their hands. That's our version, anyhow, which we think you'll agree is much better than the grimmer true story, in which an elephant trainer and clown were killed, and 15 others were injured, including two members of a TV news crew, whose helicopter crashed behind a nearby school. What's so funny about that?

BUSSTED

"You stick your right leg in and you shake it all about..."

Just two minutes into an English Premier League Soccer match, David Busst, playing for Coventry City, went for a ball near the opposition's goal and clashed with Manchester United defender Denis Irwin. "That's when the screaming started," Busst recalls. "All I remember is bawling as loud as I could, but the pain wouldn't stop." The collision had snapped Busst's right leg in half, with a noise that Irwin later described as "the crack of a whip." For Busst, whose career ended that day, the worst was yet to come. The bones had to be manipulated back into his leg, then straightened before a splint could be fitted and a painkilling injection administered. "I had seven operations over the first two weeks, another five in the next month and another three since," he remembers. The nearby Manchester goalie later had to undergo counseling to help him recover from the trauma. It took a full nine minutes for groundskeepers to wash Busst's blood from the field.

God saw the name; couldn't resist

47

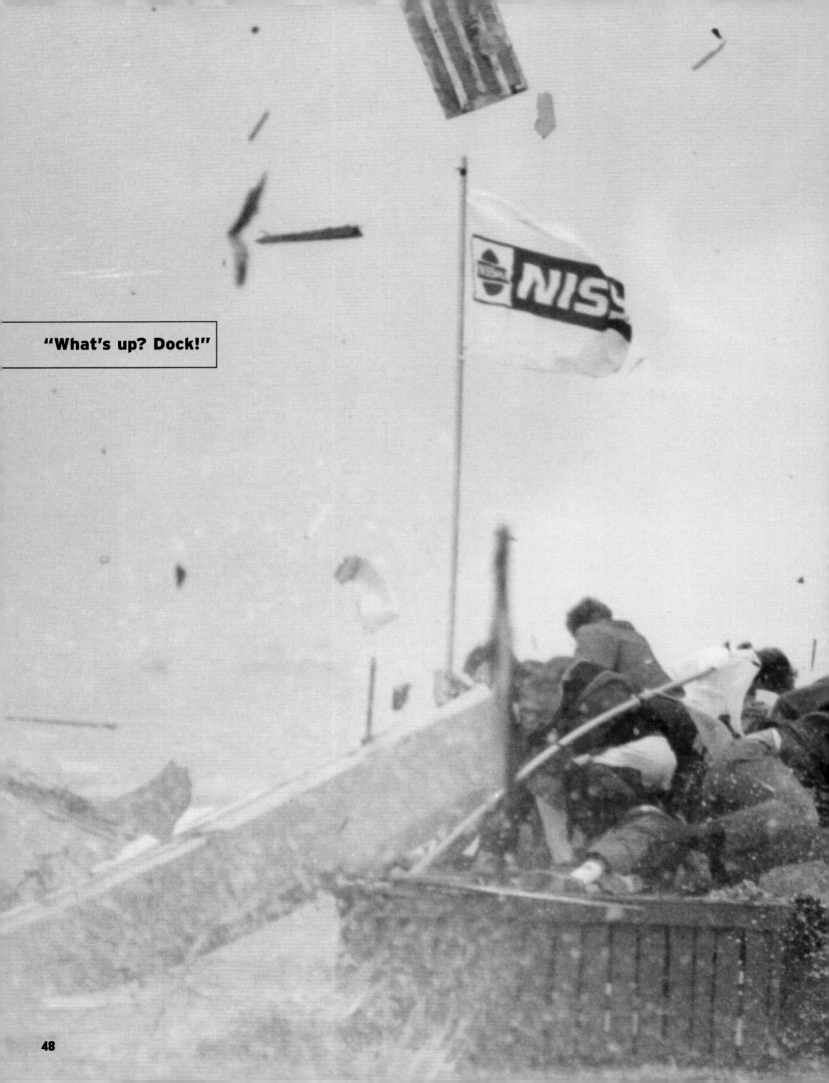

"What's up? Dock!"

WHEN THE SHIP HITS THE FANS

Final grades for the Canadians: Hockey, A+; forestry, A+; baseball, B; speedboat docking, D-.

Canadian Daniel Brossoit, a 29-year-old building contractor and former Grand Prix speedboating champ, had his heart set on winning the 53rd annual Valleyfield Regatta before a cheering crowd of hometown fans. Brossoit, who hailed from the nearby village of St. Timothee, was the odds-on local boy and a big favorite among the spectators, at least until he started killing them. When the motor cut out unexpectedly, Brossoit lost control of his boat, which then slammed into that of another racer, American Jimmy King. Brossoit was killed instantly. Next, King's boat flipped and crashed into the dock, killing one onlooker. No wonder Canucks prefer their lakes frozen, eh?

> "When I tell you guys to 'lean left,' I always mean *my* left."

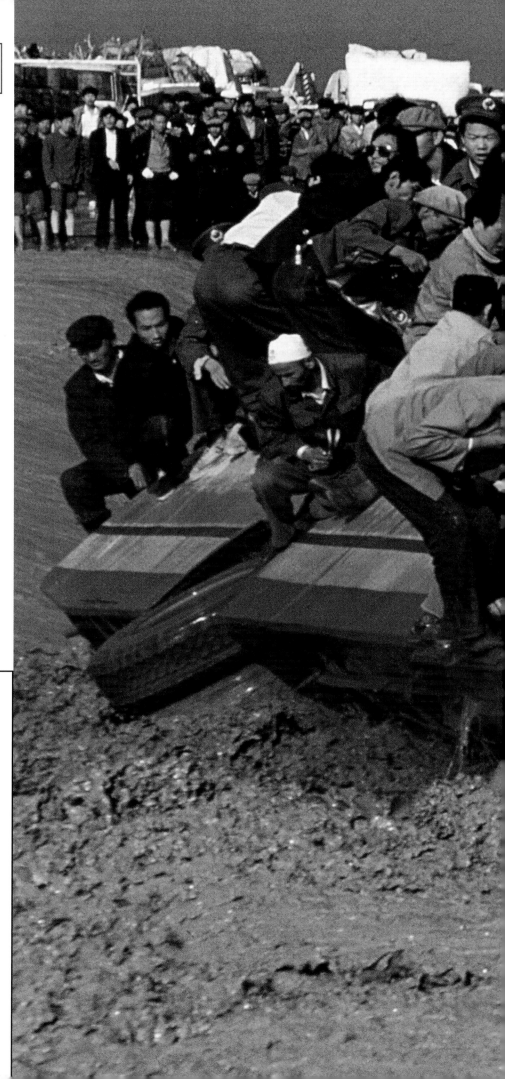

BUS SLOP

First they got busted trying to sneak their entire neighborhood into the drive-in...now this.

It's amazing what you see when you manage to drag yourself away from those VH1 modeling shows and get outdoors. In 1992, a Frenchie named René Metge and an entourage of journalists were traveling along the famous Silk Road, which connects regions of China and Russia, scoping out possible routes for a cross-continent automotive rally he was organizing. Mother Nature, no doubt incensed to discover a Frenchman in the otherwise pristine region, unleashed her fury, flooding the mountainous region with heavy rains and sending a river of mud coursing through the road. Metge's journalists, sitting on their thumbs and riding out the storm, were freed up to snap this shot of a local bus driver taking his helpless passengers on an unintentionally amphibious romp across the road. The result was exactly what you'd expect: Several passengers were killed.

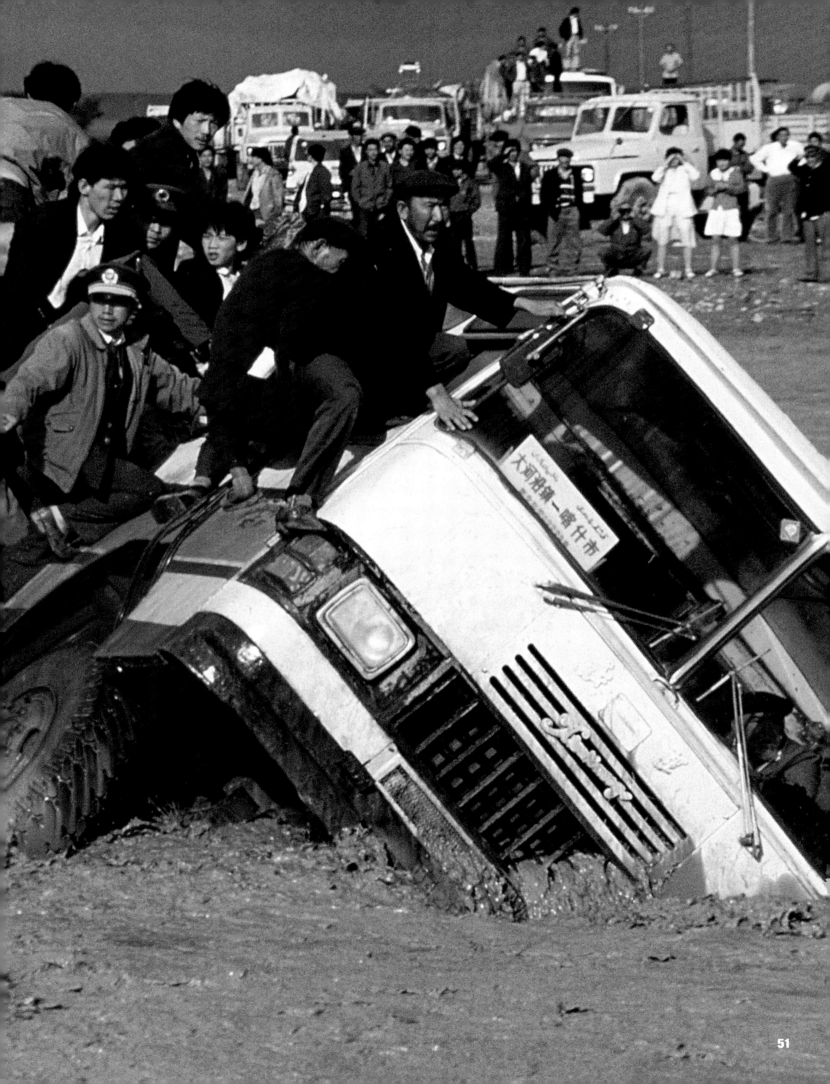

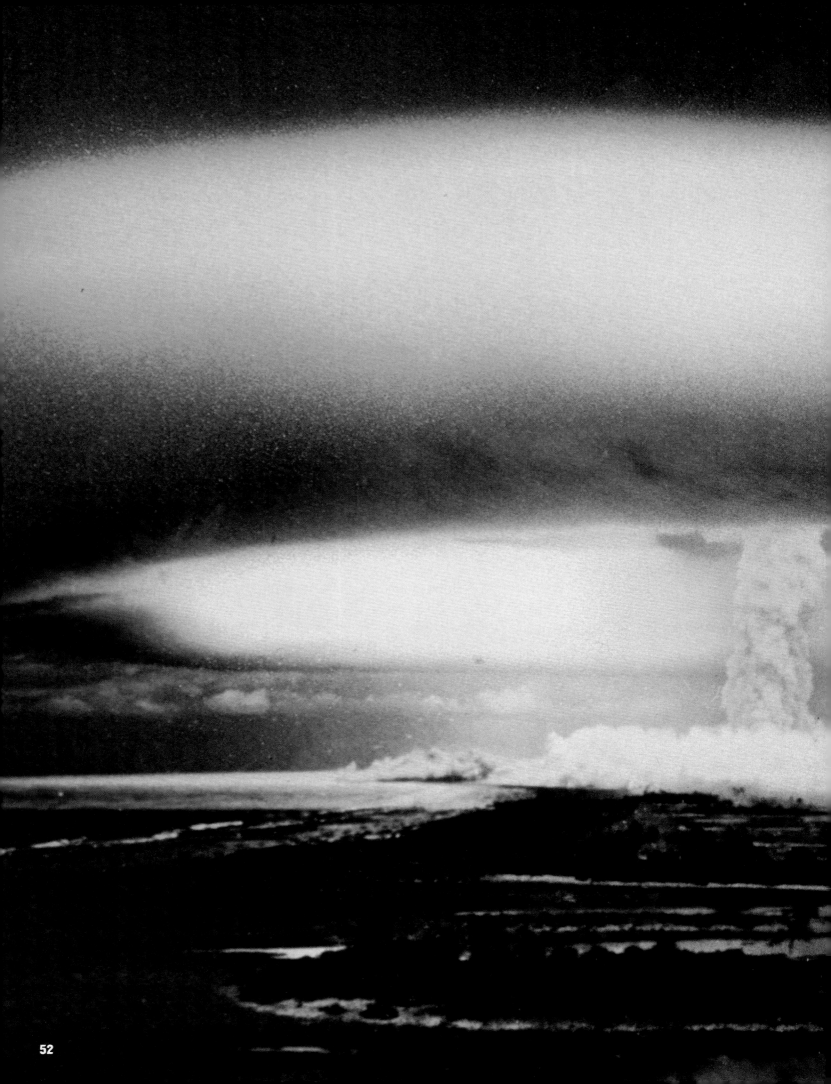

"I WANTED A BUD LIGHT!"

Vacations on Pacific Islands can be a real blast.

The most frightening aspect of this early '70s nuclear bomb test is neither the unimaginable destructive power it unleashed nor the decades of dangerous radioactive contamination it left behind. No, the really scary thing is that it was conducted by the French. In fact, those perfumed, wine-guzzling cowards have been building a nuclear arsenal for about 40 years, testing their weapons near the Mururoa Atoll in the South Pacific. Not surprisingly, France and nuclear bombs have mixed about as well as Sid and Nancy. In 1985, the Frenchies finally found an opponent they could beat when their Inspector Clouseau secret agents blew up the Greenpeace ship *Rainbow Warrior*, docked in a New Zealand harbor during a non-violent anti-nuclear protest, killing one crew member. Then in 1995, three years after the end of an international moratorium on nuclear testing, they started blowing up islands again, enraging world leaders. Today, France has about 500 warheads, ranking it third in the world, far behind the United States and Russia. But French nukes are nothing to worry about— countries rarely launch missiles of any kind during unconditional surrenders.

"I'll have the beef Stroganoff and the salad, and just bring me a cupcake for my other face."

BETTER THAN ONE

See what happens, Tommy, when you touch yourself in places you aren't supposed to?

We've seen bad facial hair before, but this is ridiculous. Zhang Ziping, the peculiar-looking Chinese fellow in this 1981 photograph, was simply born with two faces. Note the second set of teeth on the right side of his face, crowned with a parasitic head of hair. Cases like Ziping are considered rare variations of Siamese twins, in which one of the "twins" starts off as a cyst inside the other. These cysts sometimes form tumors in the body that sprout teeth and hair, and in even rarer cases, have been known to form into complete fetuses. In Ziping's case, surgeons operated successfully to remove the cheeky bastard, enabling Ziping to realize his lifelong dream of reducing his toothpaste and shampoo expenses by half.

FACE OFF

Just one of the more than 80,000 regular folks who get face-lifts every year...hint, hint.

With all the euphemisms flying around these days—"image enhancement," "cosmetic resurfacing," "getting a Cher," and so on—it's easy to forget that a face-lift is just what it sounds like: a *face lift*. Observe this procedure, performed in Paris in 1992 at the St. Antoine Hospital. The doctor scrapes the skin and underlying tissues of the patient's face away from the muscles below, working through incisions in her scalp. Soon he will literally lift and re-drape the separated skin and tissues higher on the patient's face, snip off any extra skin with tiny scissors, and staple shut the incisions. A couple of months of smile rehab, and presto: She's fresh-faced and ready to screw around with her daughter's boyfriend. Ah, science.

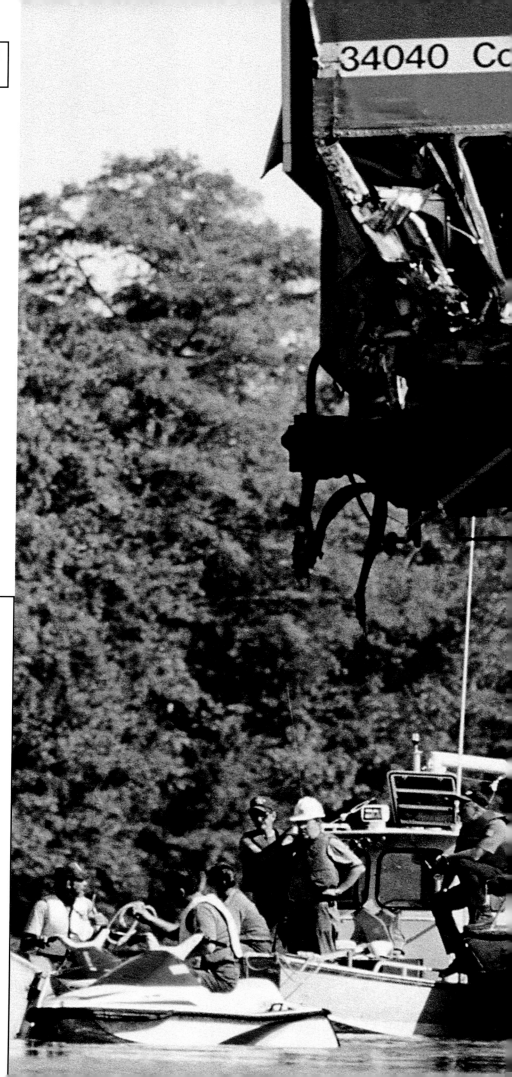

"A dollar if you can jump up and touch that."

BRIDGE OUT OVER TROUBLED WATER

As if Amtrak can't come up with spectacular, deadly accidents on their own, on September 22, 1993 they got help.

The worst American train wreck in the last 20 years occurred on a bridge between the Mobile River and the Bayou Canot ("Can too!") in southern Alabama. Just before the Los Angeles-to-Miami Sunset Limited was due to come along, a barge accidentally rammed one of the 84-year-old bridge's support pillars. The bridge was weakened mortally, and collapsed as the train passed overhead; the locomotive burst into flames, and several cars of the train plunged into the brackish swamp, killing 47 passengers and injuring 153. In this photo, taken the following day, rescue workers search for missing people to no avail.

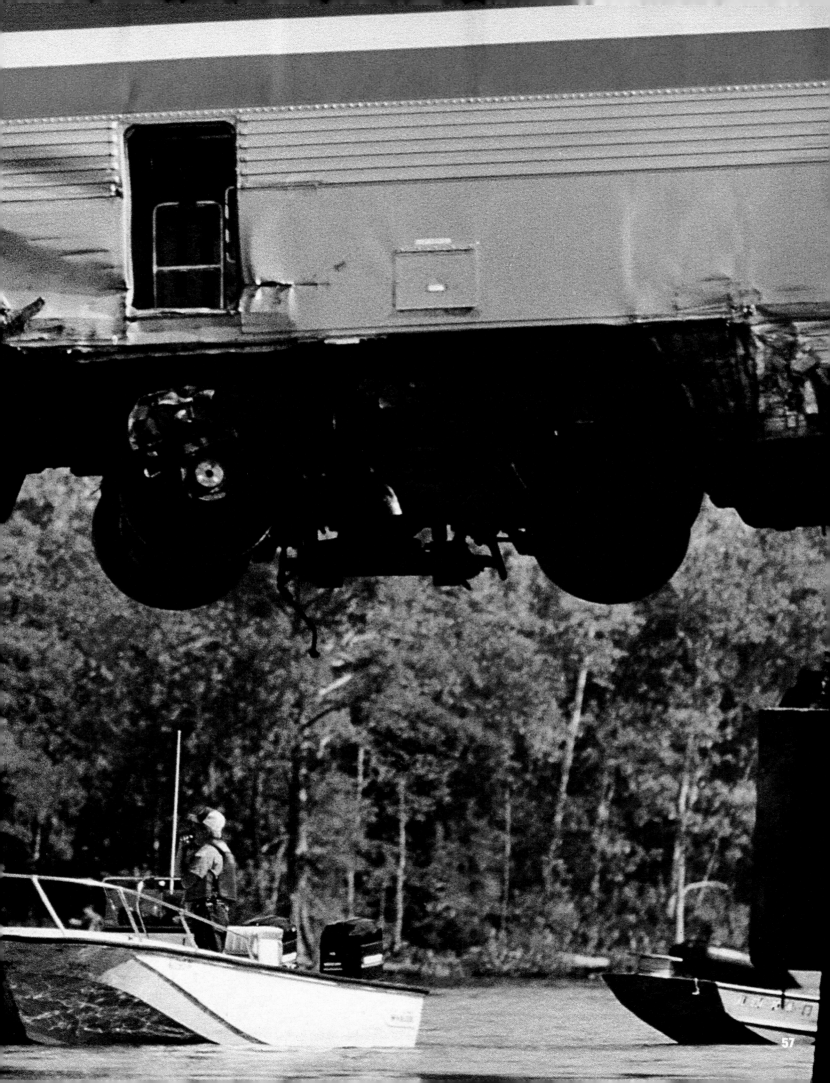

GROUND MEAT?

If the chute opens, he's a BASE jumper; if not, he's a worm smorgasbord.

To become a BASE jumper, you must leap off each of the four types of structures that form the sport's acronym—Buildings, Antennas, Spans (bridges) and Earth (cliffs)—after first (this part is apparently critical) strapping on a parachute. On any given jump, the idea is to free-fall for as many seconds as your balls can stand before pulling the ripcord. With 21 participants killed nationwide to date, BASE jumping enjoys one of the sporting world's highest fatality rates, second only to professional javelin catching. But poking death in the eye is exactly the *point*, as expressed by the scientific formula $T=VF/S$ (Thrill equals Velocity times Fatality rate divided by Safety precautions). Here, expert BASE jumper and Hollywood stuntman Moe Vitello enjoys a moment of free-fall adrenaline; two seconds (approximately 63 feet) later, he pulled the cord and landed safely on the streets of L.A—a prospect far more dangerous than the jump itself.

KLUM HITHER

Notebooks out, class. Today we will be studying German expressionism.

Date of Birth: 6/1/73
Hometown: Munich, Germany
Height: 5'9"

#1 claim to fame: Inducing cardiacs with her scorching *Sports Illustrated*'s swimsuit issue and Victoria's Secret catalog appearances.

Quote (on growing up): "Nudity was a common thing. We went camping on nude beaches in Italy. When my parents were still sleeping, I'd just go outside and run to the beach without anything on."

Why the tooth fairy's pissed at her: To this day, Heidi carries her baby teeth around in a leather pouch for good luck.

Predatory behavior: Heidi once swam with 20 sharks while filming an E! special.

A little thought to warm you up on a cold day: "When I'm waiting in line or brushing my teeth, I'll contract my butt muscles."

"But Doctor, I'm just here about my hangnail."

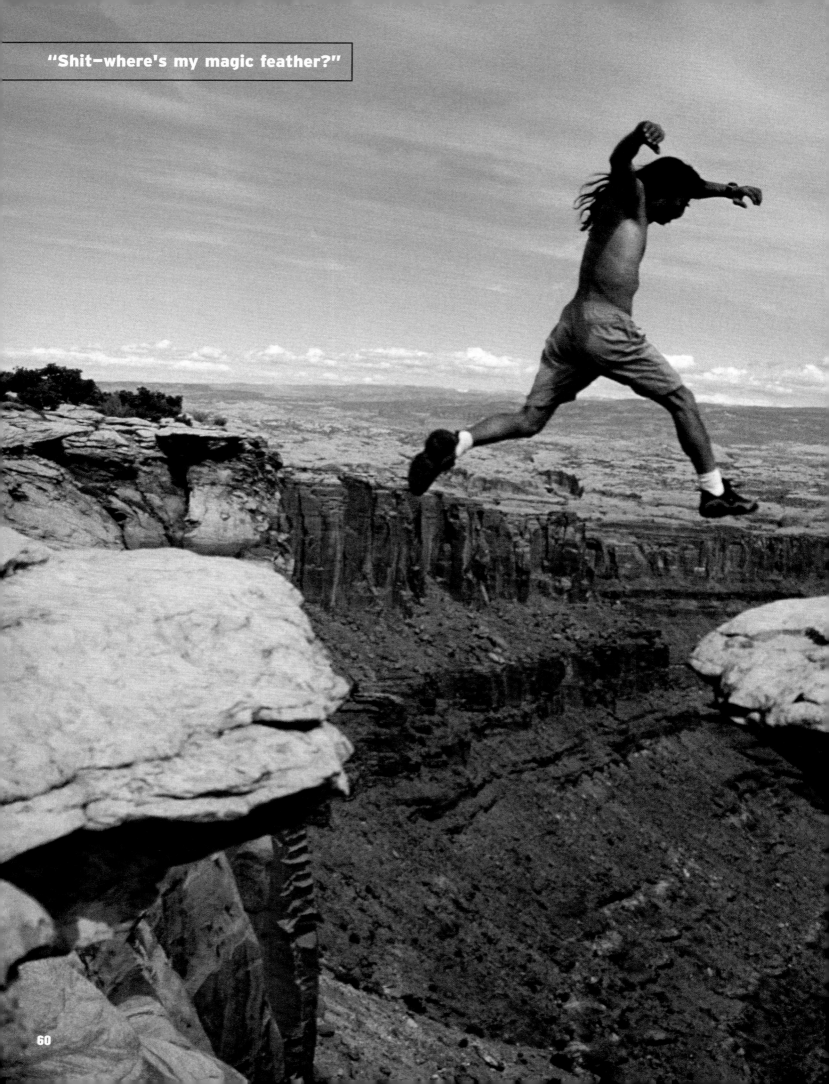

"Shit—where's my magic feather?"

JUMPING JACK ASS

Because there just aren't enough natural ways to die.

Moab, Utah, and its surrounding wilderness used to be known as the place where Butch Cassidy hijacked the Colorado ferry. Today, it's become a haven for adventurers of every stripe: white-water rafters, mountain bikers, hikers, and, as we see here, the occasional chasm jumper. This guy successfully pulled off Wile E. Coyote's wet dream, vaulting over a crevasse 400 feet above the base of Long Canyon (the spot of that final scene from *Thelma & Louise*). Like people who enjoy BASE jumping, walking tightropes without safety nets, wearing Red Sox caps into Yankee Stadium, etc., this guy can't be accused of a testicle shortage...only of a subpar helping of brain cells.

SOFA SO GOOD!

For the couch potato who has everything: A couch tomato.

Name: Natalia Cigliuti
Date of Birth: 9/6/78
Hometown: New York, NY
Height: 5'8"

#1 claim to fame: Her impressive arc of halter-top-heavy roles on *Saved by the Bell: The New Class*; *Beverly Hills, 90210*; and *Pacific Palisades*.

Quote: "I like a guy who knows how to spend money and have a good time."

Close encounters of the odd kind: On a movie shoot, Natalia once worked with Hair Club for Freaks client Dennis Rodman. "He was cool. We went out one night, and he just kept ordering bottles of wine."

Birds of a feather: "Lately people keep telling me I look like Teri Hatcher or Catherine Zeta-Jones. I can live with that."

Nicknames: "Tali. But my parents are from Uruguay, and my Spanish nickname is Nati. Even my nickname is bilingual."

Overstuffed cushions, smooth padding, and plenty of back support: Our couches are the cream of the crop.

CROCODILE
TEARS

Lest we forget the simple joys of watching one animal being killed and eaten by another.

If this shit-out-of-luck caiman was banking on the notion that cats don't like water, it's no wonder he ended up as a chew toy. Jaguars, like the Amazonian specimen here, are the most water-loving members of the cat family, and excellent swimmers. The Warren Beattys of the animal kingdom, jaguars are solitary animals that meet only to mate. They hunt primarily at night, and they love surf and turf; their prey ranges from cute woodland creatures (deer, pigs, sloth) to slippery river folk like fish, turtles, and, of course, crocodilian types like this juvenile caiman. The best part of eating alligators and their ilk? The hide makes a stylish doggy bag.

"Could someone dial 911 for me?"

RADICAL KNUCKLE-CRACKING SOLUTIONS

We've heard of farmers working their fingers to the bone, but this is ridiculous.

Damn it, we're telling you for the last time: Turn the machine *off* before you try to replace a detached conveyor belt. Having ignored that sage advice, the farmer whose hand we see here got a surprise early-severance package. Oddly, the accident was completely painless...just kidding. Oh, well: The poor sap's knuckleball may have lost a step, but, on the plus side, the next time his pinkie gets caught in a Chinese finger trap, he won't feel any pain...hell, he won't even have to be in the same state. Our sources say that one finger was successfully reattached, ensuring that at least he won't have to be fitted for a prosthetic nose-picker.

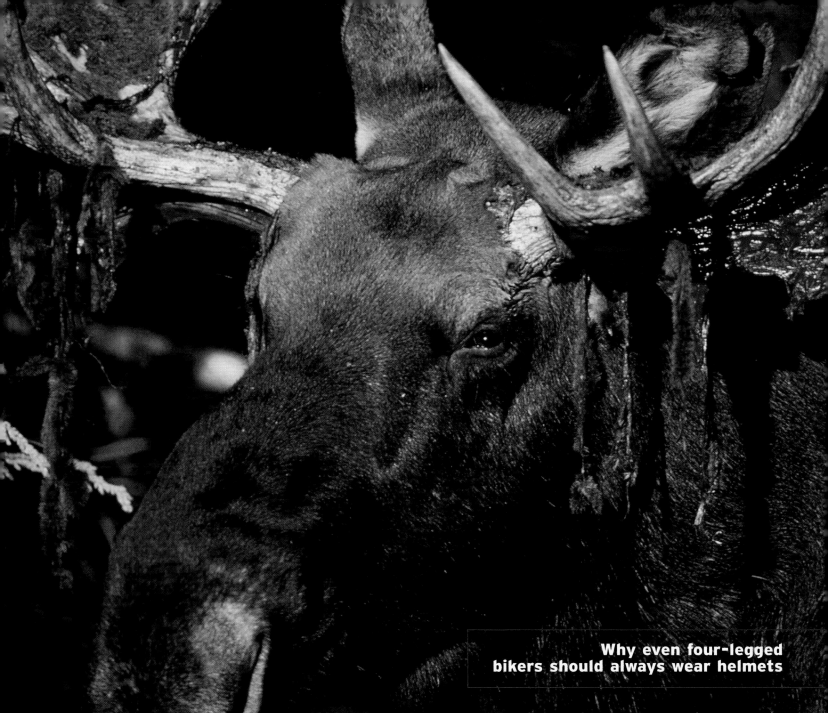

Why even four-legged
bikers should always wear helmets

CRANBERRY MOOSE

A nice rack...the gift from Mother Nature that unwraps itself.

If you're a bull moose, size matters plenty. No, not the bony growth between your legs—the one on your forehead. An adult bull's antlers serve the same purpose as your paycheck, namely, to impress females and intimidate sexual rivals during rutting season. Moose antlers are no joke, even if you're a moose, too: They can reach six feet across in some cases, and at approximately one pound per inch, that's a shitload of extra head weight to carry around 24-7. (Just ask Jay Leno how *he* feels). The Pam Anderson of the great outdoors, a moose drops its antlers and grows an entire new set each spring. Our moose here is in the late-summer process of shedding the soft, bloody "velvet" covering his rack. The new antlers will harden and Wally here must sharpen them on trees before he can reliably sprint headfirst into other bulls or unwary hikers. The hassle we men put ourselves through for a little action....

BAD ALTITUDE

This is a picture of: a) Stevie Wonder, master crop-duster, b) a kamikaze pilot with low self-esteem, or c) an inept but lucky Guatemalan peacekeeper.

Answer: c. When a Guatemalan earthquake killed 25,000 in 1976, this road served as a makeshift runway for planes bringing in emergency personnel and supplies. The photographer, in Guatemala to shoot the relief effort, had landed on this same "runway" just minutes before this incredible collision unfolded. Nobody was seriously injured, but the truck driver did shit a sizable brick.

"Wait, this isn't the Autopilot—it's the cigarette lighter!"

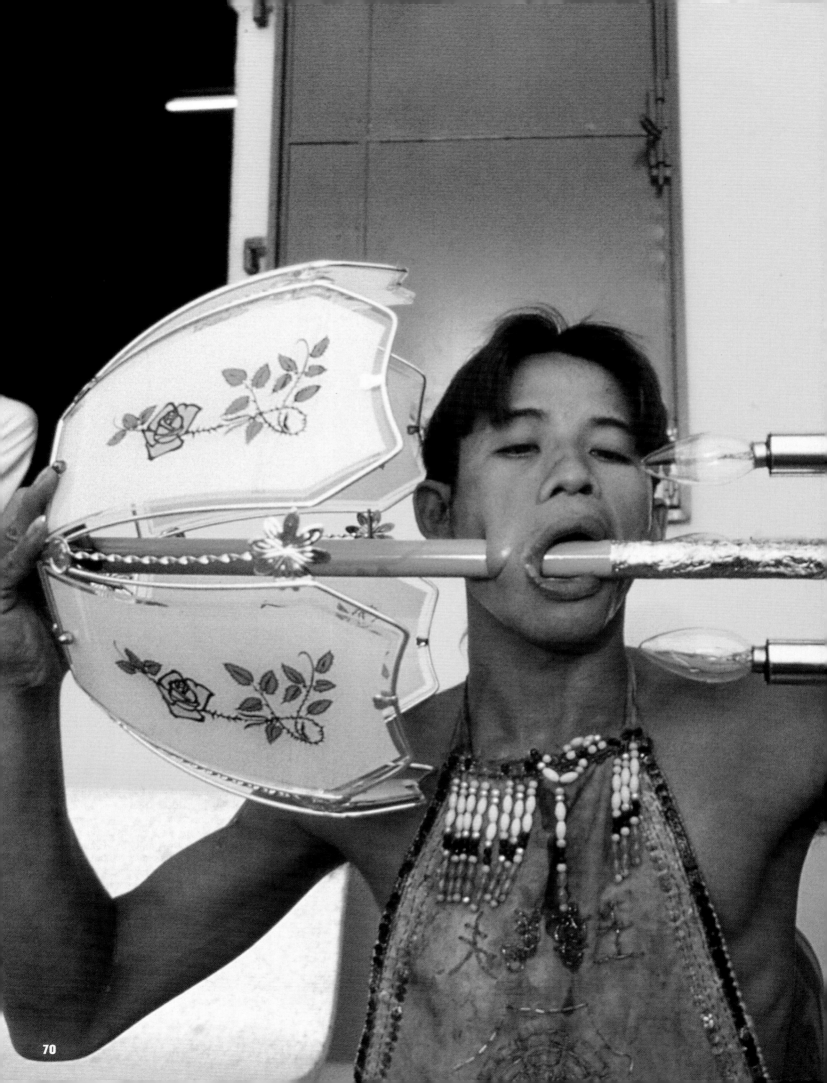

LIGHT LUNCH

Munched on any good animals lately? At Phuket's bizarre Vegetarian Festival, tofu eaters will go to amazing lengths to get you to yak 'em back up.

The Thai island of Phuket—quit snickering, you in the back—is so beautiful, claim local yokels, that nine emperor gods come down from on high once a year to check out the action. The gods' nine-day visit is commemorated by the Vegetarian Festival, in which celebrants show their piety by walking on red-hot coals, climbing razor ladders, and punching odd shit through their faces. Lampy, here, like hundreds of his fellow "mediums," first drove a stainless steel spike through his cheek, then screwed in the lamp. Before piercing each new face, these communal spikes are first sterilized, it should be noted, by a quick wipe with a greasy hamburger wrapper. (OK, OK, they use rubbing alcohol—but still, in a country with legendary AIDS trouble, you gotta wonder.) When the parade ends, the gods go home, everybody sobers up, and the crowd, sated and at peace, is free to drift back to their sex tours.

FALL GUY

Because there comes a time in every man's life when he's just got to weld his legs into a useless wedge of fiberglass and throw himself over a waterfall.

Looking for a new way to test your 'nads, get adrenaline spurting out both ears, and maybe meet the Grim Reaper himself? If so, we strongly recommend a whitewater kayaking trip to Ecuador. Thanks to wacky mountain/jungle juxtapositions and suicidally treacherous snarls of raging Andes runoff rivers, Ecuador has become a favorite playground for escaped-mental-patient kayakers like the nut job you see here plunging down one of the Misahullalli River's waterfalls. True, just to reach the water, you have to machete your way through miles of dangerous Amazonian terrain, wade through waist-deep mud, and eat monkey brains. (OK, that last one's optional.) But once riverbound, you're in the clear—as long as you're okay with class 6 ("constantly threatening death") rapids, 30-foot waterfalls, jagged rocks, typhoid-fever-carrying insects, poisonous snakes...

"Merrily, merrily, merrily, AAAAAAAAGH!"

"Well, at least that horrible squeaking stopped."

OILY BIRDS

J. Crew's new spring rain slicker keeps you dry as a bone, even in the most adverse weather conditions.

Some of those goofy Iraqi bullet-catchers took their anti-industrial pranks a little too far during the Gulf War. The result: The government had to hire outside help to extinguish dozens of massive oil-well fires and try to salvage the bleeding wells. In the April 1991 assignment pictured here, a team from the Safety Boss Co. of Calgary, Canada, tries to contain a spill, where the position of a damaged part is increasing the pressure, causing the well to spew uncontrollably, like Bill Clinton at a cheer-leading competition. The complicated and dangerous procedure involved removing and replacing the broken bit with a crane, and plugging up structural fissures by injecting mud. Twice, wind changes covered the men and all their equipment with the violently spurting muck, necessitating four-to-five-hour cleaning sessions before work could be resumed—again, like Bill Clinton at...oh, skip it.

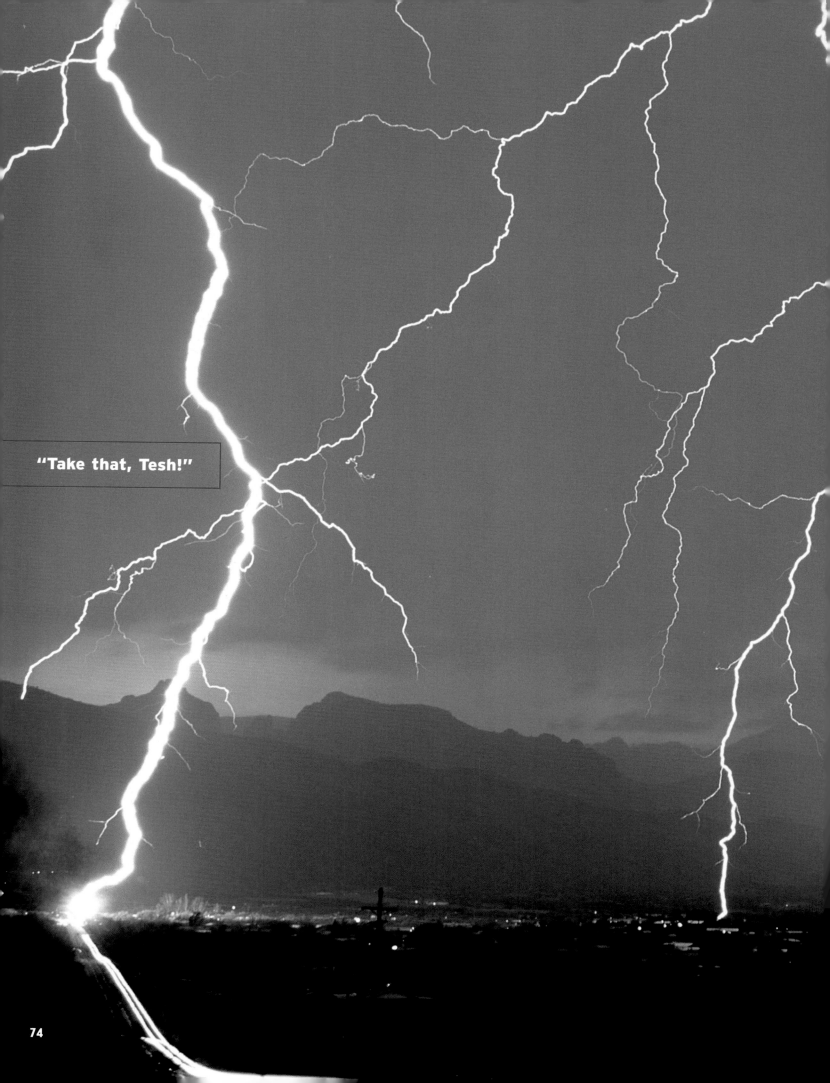

"Take that, Tesh!"

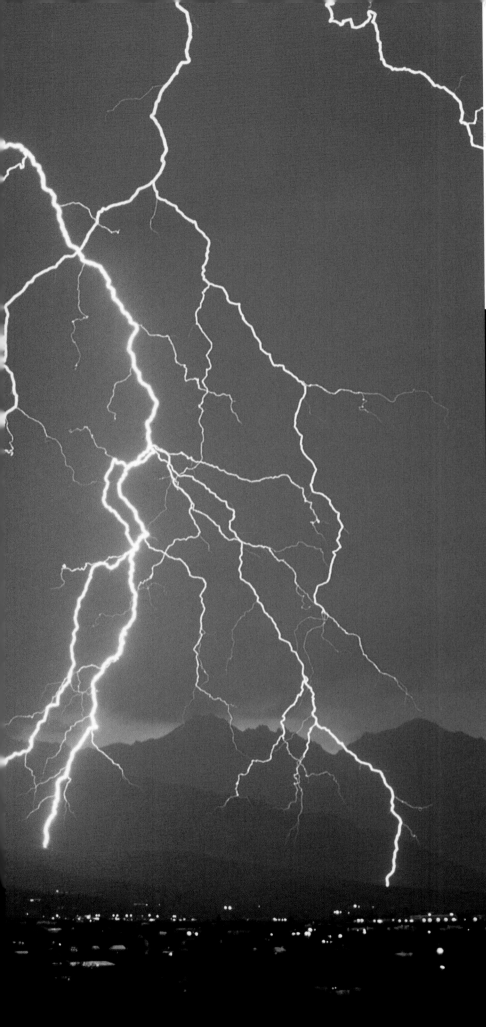

NOCTURNAL DISCHARGES

Lightning: Paragon of celestial beauty or deadly ass-toaster?

Ours is a benevolent god...but you don't want to taunt the guy. Nearly 1,000 people die each year worldwide from lightning strikes. Luckily, the average person has only a 1 in 3 million chance of being struck—roughly the odds of a new Dan Aykroyd movie being watchable. But your chances of being struck increase dramatically if you do something like golf, hump a flagpole, or blaspheme. Surviving a lightning strike—and most people do actually survive—often leaves victims with loss of memory and coordination, chronic numbness, and pain. And if you get struck once and survive, don't believe the old saying that lightning never strikes the same place twice: Roy "Hot-Pants" Sullivan received *seven* 100-million-volt jumpstarts over a 35-year span, at various times losing his eyebrows and toenails, suffering burns all over his body, and singeing his hair. Sadly, Sullivan eventually committed suicide after the woman he loved, um, bolted.

EVEREST IN PEACE

In the neverending quest to conquer the world's grandest teton, what goes up doesn't always come down.

History has immortalized the name of Sir Edmund Hillary, the first of more than 700 adventurers to climb the fabled Mount Everest. But for the unidentified Popsicle pictured here, one of 150 climbers who have died en route to the summit over the years, there will be a different kind of immortality. Common practice, resulting from equal parts respect and practicality, is to allow those iced by the mountain to remain permanently attached to their unrealized dream. This number is scheduled to grow: More than 30 people went to their graves on Everest in the last five years, 15 in 1996 alone. The bodies, along with an estimated 50 tons of trash, are gradually transforming Everest into earth's most prominent shit-heap. And every year, another 150 climbers make a run for the top, leaving behind, among other things, an estimated 6,600 pounds of feces. Some is brought down by Sherpas to be used for fertilizer–*think about baseball, think about baseball*–but the bulk remains frozen to the mountain's face. Just one reason Everest, at 29,035 feet, is now seven feet taller than when last measured in the 1950's.

"T-t-t-talkin' about my g-g-g-eneration..."

"Aww...how the hell are we gonna get this thing in the veal pen?"

CALF AND A HALF

This freak cow raised a terrible bookkeeping dilemma for one Iowa farmer: Just how many head of cattle did he own?

In April, 1998, farmer Gary Slife of Independence, Iowa, notified the press that his cow had given birth to a two-headed calf. Was it a sign from God? A horrific McDonald's genetic experiment to simplify the double-cheeseburger process? Only one thing was sure: A one-hour C-section delivery had produced an honest-to-God, living, breathing, one-bodied, four-legged, four-eyed, three-eared, two-headed calf. Old adages about two heads' preferability aside, ol' Four Eyes survived less than a week, but was much admired and pampered during his brief heyday, and died peacefully, for the veal-good story of the year. (Sorry.) Then, the horrible mootant was stuffed by a taxidermist for the benefit of science and connoisseurs of freak medical curiosities—you know who you are. Interestingly, the calf was born just seven months after Rudy, a three-eyed, two-snouted pig, who was born in neighboring Delaware County. Insert your own country-folks-inbreeding joke here.

HUMPTY DUMPED

Saboteurs, teen sociopaths and right-wing extremists from Montana: Forget about Molotov cocktails and pipe bombs. For serious anarchy, check out Riyadh's annual King's Camel Race.

Once a year, the men of Saudi Arabia suspend their usual routine of eating tabbouleh, smoking hookahs, and zipping around on flying carpets, and focus their energies on the region's most famous sporting event—the ancient and honorable King's Camel Race in Riyadh. This event is no one-mile lope around an oval...it's a 900-animal free-for-all stampede, featuring turbaned jockeys in flowing robes, crowds of screaming sheiks in the stands, and piles and piles of steaming camel dung. The race is 11-plus miles, and the winner is the first camel to cross the finish line, with or without its rider. Incidentally, for a spindly-legged, humpy, long-necked animal with fleas and a bad, bad attitude, the camel can step on it when so inclined—they've been clocked at 25 to 30 mph. Of course, if a screaming Arab clung to your back and cracked his staff across your neck, we're guessing you'd hoof it, too.

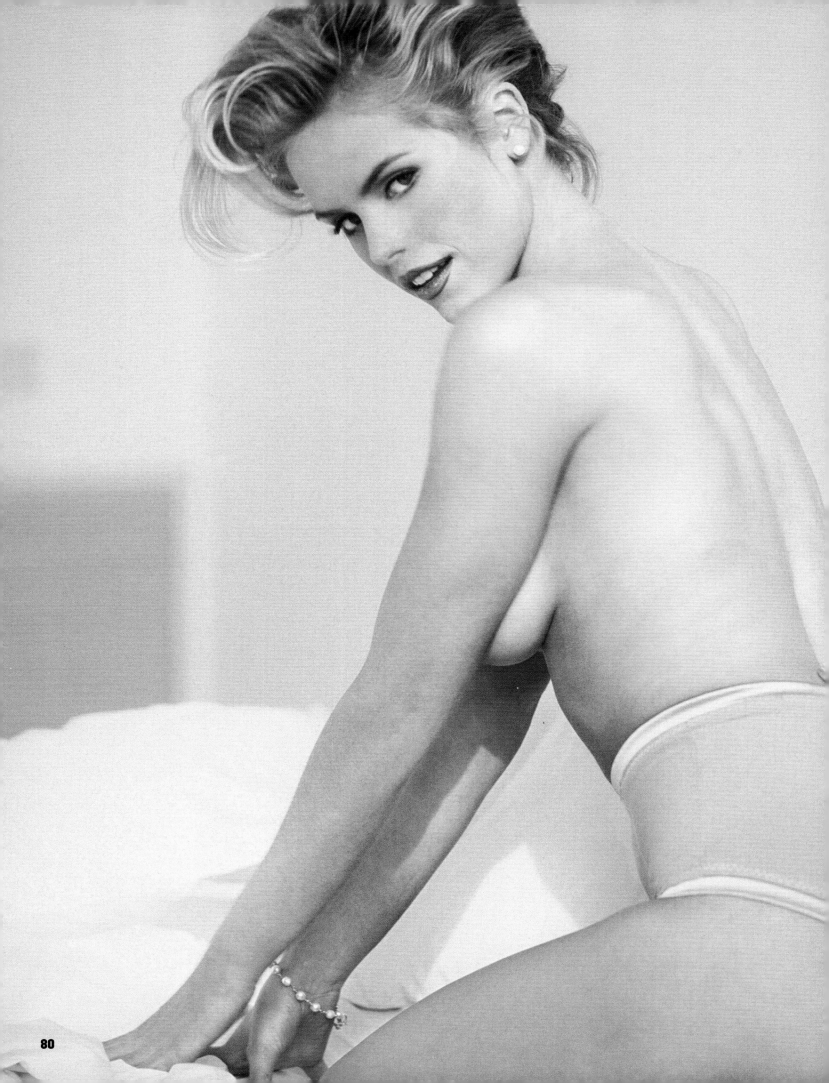

GOLLY GENA!

Getting out of bed in the morning just got that much harder.

Name: Gena Lee Nolin
Date of birth: 11/29/71
Hometown: Duluth, Minnesota
Height: 5'9"

#1 claim to fame: Warming her toes in the sand as Neely Capshaw on *Baywatch* from 1996 to 1998.

Quote: "I always felt bigger than other girls. Over the years, however, I've learned to use that to my advantage."

Where she learned to drape herself over a washing machine: On *The Price Is Right*, where she started her TV career.

Hostess' cupcakes: Gena sported a bikini while hosting the USA Network special *The 50th Anniversary of the Bikini*.

Stroke *Baywatch* producer Greg Bonann asked Gena to do during her 1996 audition: The breaststroke.

How Gena sent computer nerds into a tizzy: As a prank, she announced that there would be a live Webcast of her baby's birth.

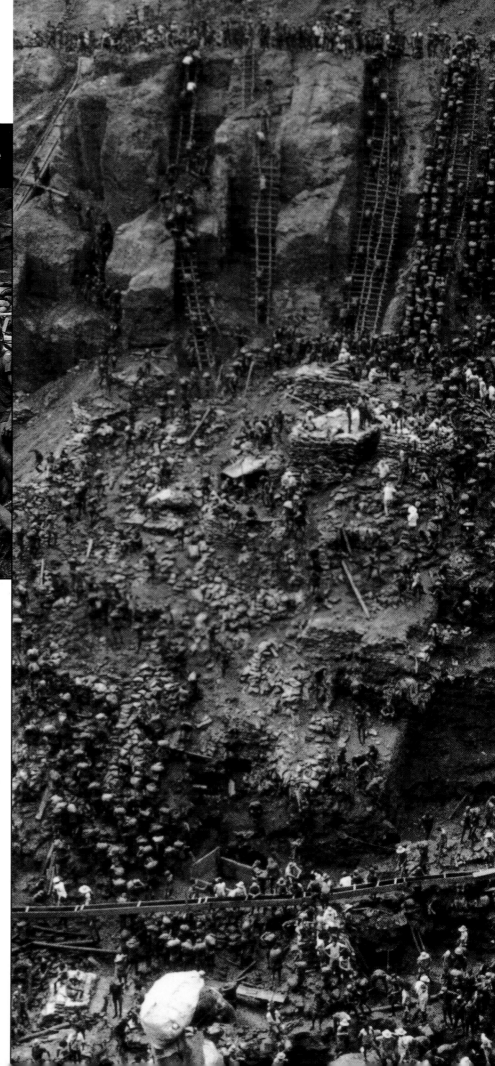

In vain, the workers struggled to keep pace with Mr. Brando's growing appetite for Ding-Dongs

TAKE THIS JOB AND SHOVEL

Brazilian gold miners make money the old-fashioned way: They scrape it up out of the ground.

Need a really big hole dug? Just tell 50,000 Brazilians you struck gold, throw down a pile of shovels, and get the hell out of the way. Since 1980, when a farmer in Serra Pelada found a gold nugget in a stream on his property, the state has become a South American Klondike. But this gold rush is organized: An area the size of a football field is divided into 65-square-foot plots, worked by private concessioners who are only allowed to dig straight down and must haul the excavated earth out along muddy, precarious routes. Tedious, dangerous, backbreaking labor...sounds just like your job, huh? But there's a difference: Diggers in a Serra Pelada concession frequently uncover cabbage-size gold nuggets and sometimes larger ones, weighing as much as 140 pounds. Put that in your 401(k) and smoke it.

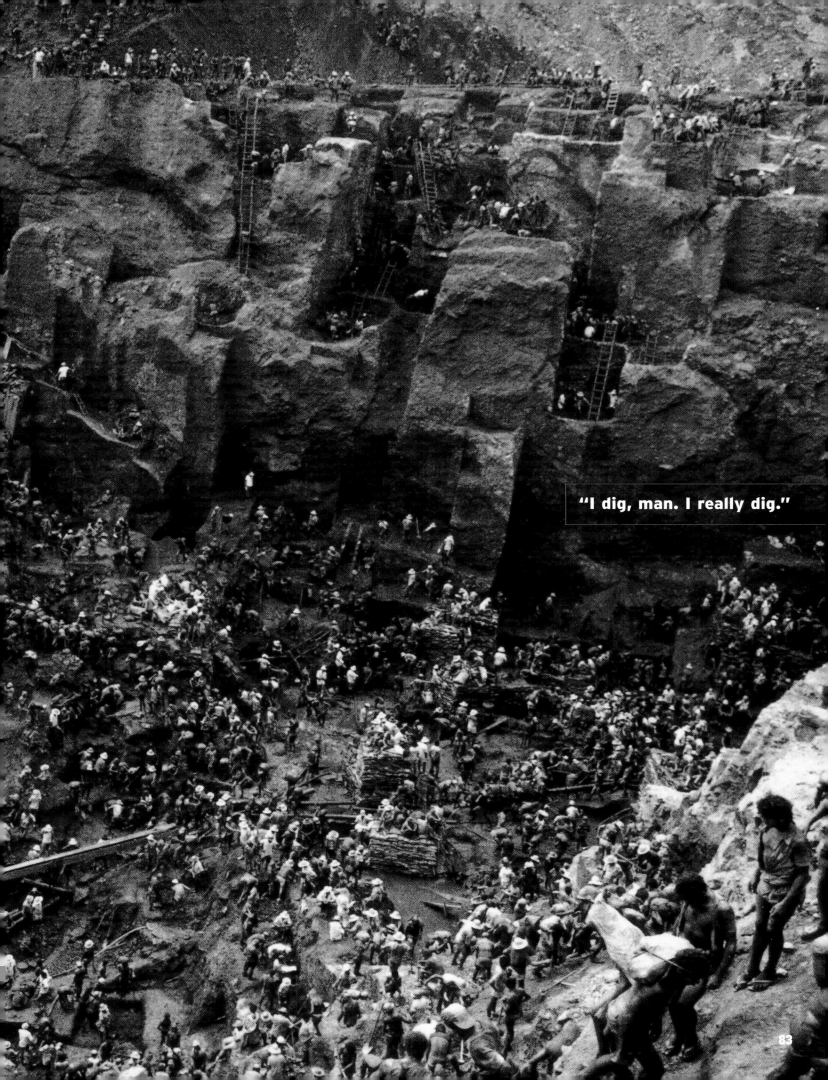

"I dig, man. I really dig."

83

OF LICE AND MEN

**How many lice can dance on the head of a human?
Buddy, your whole family ain't got enough fingers
and toes to count 'em.**

Pencils ready, class? Of the 3,000 known species of lice, about
300 are classified as *Siphunculata*—sucking lice, the kind that
feed on the fresh blood of mammals. Of these, two species live
exclusively on the blood of primates, though a lot have probably
been found at one time or another on the body of Bob Dylan. The
two monkey-lovin' species are: *Phthirus pubis* (your girlfriend
knows all about these—trust us) and *Pediculus humanus*, the more
elongated and active hair and body lice that kids seem to enjoy
getting, pictured here. If you hanker for a headful of teeny-tiny
pets, just sit tight: Breeding them's easy. Females typically lay
about 300 eggs over a few weeks. It takes about a month for an
egg to go through its larval stage, hatch, and become sexually
mature, at which point it moves out, finds a mate, and starts
knitting hundreds of baby sweaters for its own coming brood. If
this cycle is allowed to continue unchecked, body lice can form
grapefruit-size clusters that have been known to drain all the
blood of an adult human in 10 to 12 days. Actually, that's a
complete lie—but we think it would make a great movie....

PLUMMET PUDDING

If your friend jumped off a cliff, would you do it, too? These days, increasingly, the answer is yes.

We've already shown you one picture of a BASE jumper—the nutjob parachuting off a city building on page 58. Thought you might like to see this one, too. This time, our human lemmings test gravity over the lip of Venezuela's Angel Falls. At more than 3,000 feet, this is the highest free-falling waterfall in the world—higher than the Empire State Building with the Sears Tower and a couple of Andre the Giants stacked on top. Before you head there to take the plunge, do keep in mind that Jan Davis, the first woman ever to make the Angel jump successfully, is now an angel herself, thanks to a later jump from an even taller monolith at Yosemite, during which her parachute did a nice impersonation of a duffel bag. Reportedly, the 60-year-old Davis had undertaken the jump to illustrate that BASE jumping is safe, marking it as the least persuasive argument since Lyndon Johnson tried to prove his love for animals by lifting his dogs up by their ears.

Australian Rules Swimming Lessons

SEVERANCE PAY

The Chinese revolution of 1911: A time of bloody battles, fiendish despots and street theater that would traumatize Wes Craven.

We're torn. On one hand, this 1912 picture of a Ch'ing imperial soldier publicly executing a rebel makes it hard for us to look back on the Ch'ing regime too fondly. On the other hand, who had helped turn that dynasty into a power a few generations earlier? None other than Pinyin Zuo Zontang, a.k.a. General Tso, the man for whom the indescribably delicious General Tso's chicken was named. Unfortunately for the Ch'ing, neither savory poultry nor public bloodbaths could save them from angry nationalists sick and tired of getting decapitated all the time. Before 1912 was over, the ruling dynasty was replaced by a republic, later to be overthrown in turn. Confucius say: "Governments come and go, but crispy chicken goodness is eternal. Thank you. Come again please."

Suddenly, he felt as if a great weight had been lifted off his shoulders...

DOUBLE
TROUBLE

Florida's Lake Okechobee: Nice place to visit, but you wouldn't want to catamaran there.

The land surrounding Lake Okechobee, the big blue dot in the middle of Florida, is flat, boring, and peaceful...exactly what you'd expect of Disney World. But don't be fooled: This is prime waterspout country, thanks to lake water and latitude. An amateur photographer used the lightning as a flashbulb to snap this photo in 1991. The nature of the beast: Formed when a tornado originates or passes over a body of water, waterspouts travel at a poky 15 mph or so, but can contain 200 mph winds, reach heights up to 10,000 feet, and produce a vortex strong enough to suck hot magma out of the center of the Earth and spew it into the stratosphere*. Dog-paddlers, you have been warned.

*"Vortex" fact not even remotely true.

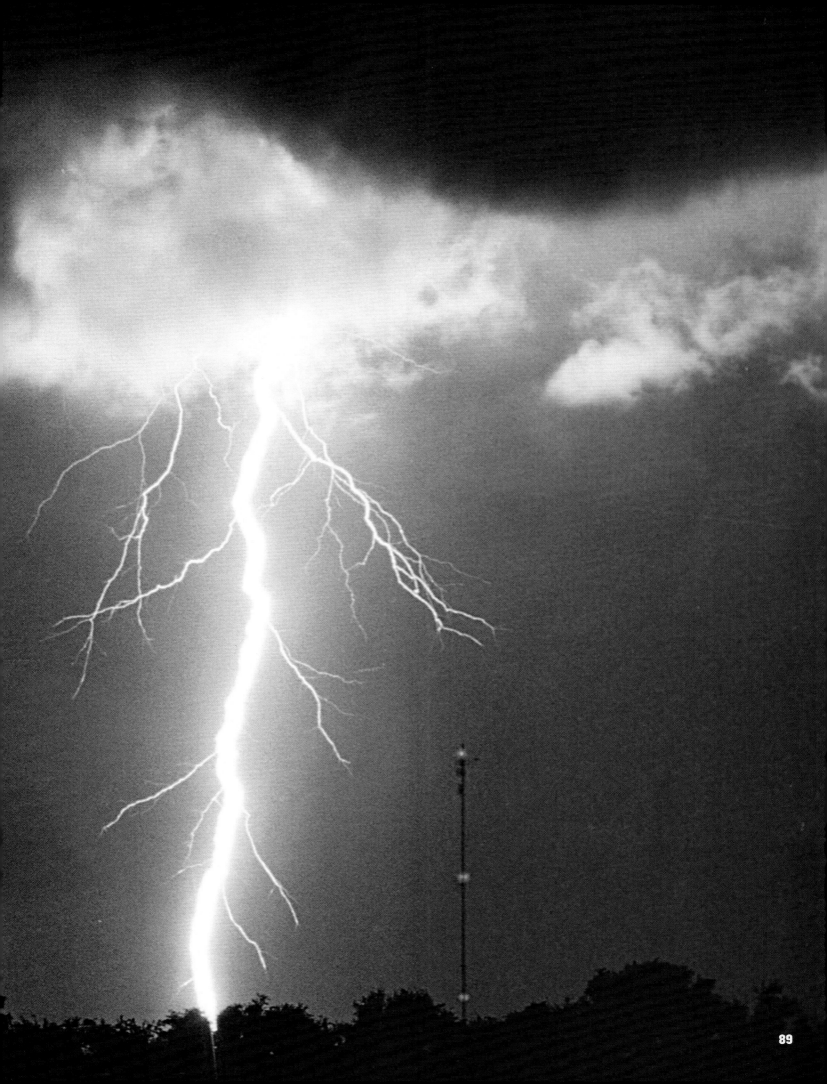

NICE LUNGS

Funny the things you find in your own driveway these days

Name: Susan Ward
Date of Birth: 4/15/76
Hometown: Monroe, LA
Height: Height: 5'4"

#1 claim to fame: Acting on surf-friendly television series (*Sunset Beach*, *Malibu Shores*); and in films (*The In Crowd*, *Poison Ivy: New Seduction*)

Quote: "I'm a pretty sweet girl, but I'm not that sweet."

Where she learned how to handle the catwalk: On her junior high school dance/drill team, the Kit-Kats.

Dirty hobby: In her teens, Susan raced on the BMX bike circuit.

Growing up in a zoo: At Susan's folks' farm in Monroe there are dogs, cats, exotic birds, and a monkey.

Local girl makes good: In 1998, the mayor of Susan's Louisiana hometown proclaimed a "Susan Ward Day," and Susan was made grand marshal of the town's Mardi Gras Parade.

Funny the things you find in your
own driveway these days

HELLFIRE AND BRIMSTONE

Ancient Hawaiians knew which sex had the real power.

According to Hawaiian legend, the numerous volcanoes on the islands are caused not by molten rock under the earth's crust, but by Pelé. Why does the Brazilian soccer great get blamed? Answer: He doesn't! We tricked you! We're talking about Pele, the one with no accent mark, the beautiful but tempestuous Goddess of the Volcanoes who has been revered and feared by credulous natives for centuries. Immortalized in countless ancient Hawaiian songs and chants, this formidable chick deity causes earthquakes by stamping her feet, and volcanoes by digging with her magic stick...about the same time every month, we betcha. Pele can be seen in all her gas-belching glory at the summit of the Kilauea volcano, where she occasionally burps up 2,000° F molten-lava fountains. Here, we see a geologist getting a taste of the little lady's wrath during the eruption of Mauna Ulu, circa 1970. You can bet it was the last time the poor bastard left the toilet seat up.

"Doc, it burns when I do this."

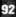

SONATA IN BEE MAJOR

There's been a growing buzz lately about clarinet player Norm Gary.

Musicians can't rely on talent alone to make a living: Success also depends on practice, determination, luck, and—perhaps most important—buzz. That's where Norm "The Bee Man" Gary makes his mark. Unlike today's lazy longhairs, this musician hasn't forgotten the craft: building his discipline of performing while frosted with live bees. Seen here tootling away for dear life at the 1996 California State Fair in Sacramento, Gary, a former entomology professor, sat inside a Plexiglas enclosure three times a day and played Dixieland on his clarinet while more than 100,000 living, stinging insects crawled all over him. Gary claims he's never been stung on the eye but says, "on several occasions, I've inhaled a bee. Usually I'm able to spit it out, but once I was stung on my vocal cords." Maybe that's what inspired him to quit performing and start a new career as a "bee wrangler," managing bees on big-time movie sets. Or maybe the move from music to film was all about emulating his hero...wait for it...Sting.

"Hey, Bob, you done on that tanning bed yet?"

THE ORIGINAL
LEATHERFACE

Without the stage makeup, saurian rocker Keith Richards is not a pretty sight.

This ghoulish character was preserved in a Danish bog for nearly 2,000 years before being discovered and extracted in 1952. By that time, peat acids had turned him into human beef jerky, naturally reddening his hair and tanning his skin to something like leather. Causes of death, besides the obvious? His throat was deeply slit; experts suspect the fella was the victim of either a religious sacrifice or an epileptic sushi chef. Our buddy now rests in Denmark's Moesgård Prehistoric Museum, serving to remind patrons of an age in which religion was taken very, very seriously. How he got ahold of Marv Albert's hairpiece is a mystery scientists have not yet dared face.

ANIMAL LUST

And you thought your sex life was wild?

Compared with most of Mother Nature, even Dennis Rodman's sex life seems mundane—take a look if you don't believe us. Still not convinced, eh? Read on:

- The female gray whale chooses two males for each bout of nookie: one to do the deed, and one to hold her 45-ton body still.
- Like college students, male toads are always in heat. And like British college students, when there aren't any ladies around, they occasionally mount one another and bang away.
- During mating season, lion couples can have sex up to 100 times a day, without the aid of a single spicy video.
- The male porcupine urinates on the female to soften her quills before mating. (Ask before trying this one at home.)
- Hermaphrodite banana slugs practice "apophalation," in which one slug gnaws another's penis off and the castrated slug becomes a chick. Banana slug Jerry Springers have a field day with this sort of thing.
- Like Mrs. Black Widow Spider, the female praying mantis is known to kill her mate. The evil twist: Sometimes the mantis beheads her partner during copulation. Afterward, she devours his corpse and then lights a tiny cigarette.

For the thousandth time, Alexander cursed his lack of finge

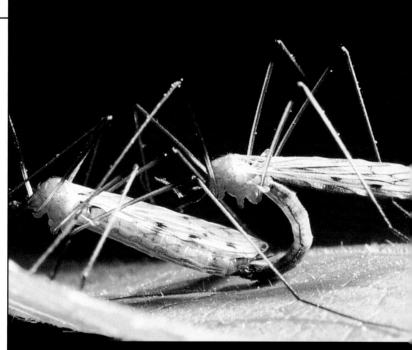

"What do you mean, 'that's it?'"

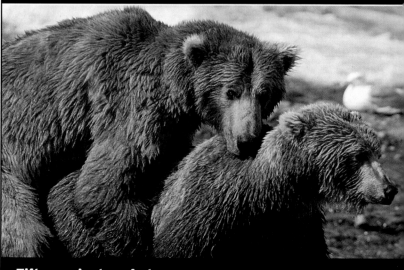

Fifteen minutes of pleasure;
three days of rug burn.

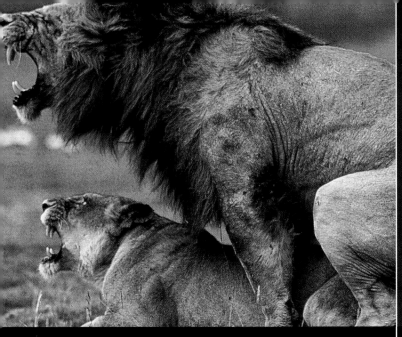

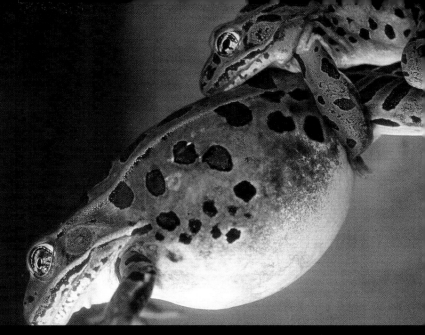

w! I thought these things were 'king-sized!'"

After six margaritas, Gordon wasn't too choosy...

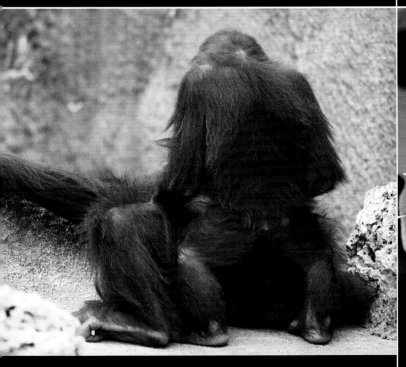

ouldn't you at least pretend to enjoy it a little?"

"Shhh...I think I hear the caterpillars..."

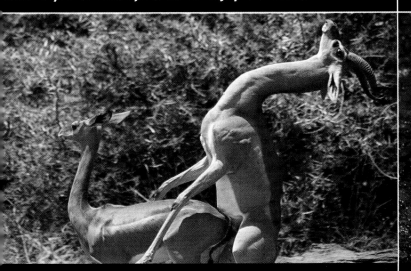

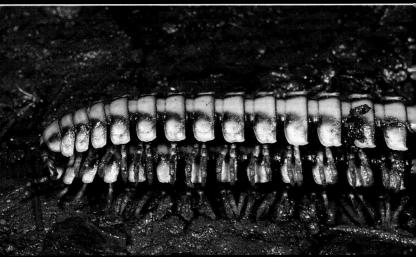

ang on...did you feel a drop?"

"Move 50 of your legs a little to the left..."

"Excuse me...you folks have any Grey Poupon?"

WHEN BOATS ATTACK

A wayward powerboat takes to the skies and turns a perfectly good yacht into boatmeal.

Talk about trimming your sails. In the thick of the Suncoast Offshore Grand Prix race off the coast of Miami, the crew of the 37-foot Wellcraft racer *Crave the Wave* was zipping along at 100 mph when she hit the wake of another racer. Losing control, she flew off-course and smashed directly into the bow of an unlucky yacht anchored nearby, the lumbering 65-foot *Tortuga*. The *Wave*'s crew was unhurt and succeeded in getting their boat back in the water with minimal damage, but the yacht sustained significant damage and two passengers were injured, presumably through slipping and falling on the Möet and caviar-spattered poop deck.

Deep inside Paul
Bunyan's Porta-John

HOLE TRUTH

What compels men to shimmy down ropes hundreds of feet into the center of the earth? Could they be...minions of Satan?

All right, all right—they're photographers in the process of accomplishing the unprecedented feat of photographing the Mystery Falls, Tennessee cave shown here, one of the deepest straight underground drops in the Eastern U.S. Between the cave's monstrous size, utter darkness, and the necessity for the right weather conditions to ensure the safety of the stalwart shutterbugs, this was no simple feat. The four-day ordeal involved rigging up a 1,700-foot network of ropes just to support the lighting. Amazingly, when the lights were turned on, these guys *did* spy the Prince of Darkness scuttling behind some rocks. If what they say is to be believed, he's not the pointy-tailed, pitchfork-wielding fellow of popular folk-lore, but rather a red-nosed clown named "Patch," who brings smiles to hospitalized kids everywhere. The oxygen level in the cave is also believed to be substandard.

Never again would Sal fiddle with the CD player during a race

HEAD OVER WHEELS

Remember: Under French motor law, at least one wheel must be in contact with the ground at all times when executing a three-point-turn.

Too much acceleration too soon causes accidents, as your first girlfriend knew all too well. Here, driver Mauricio Gugelmin learns the same lesson on the first curve of Lap One at the 1989 French Grand Prix. "I saw a gap ahead of me so I went for it...then the gap just disappeared," Gugelmin said afterward—again proving the similarity between auto-racing and teen romance. Result: The Brazilian felt his March-Judd's wheels lock, momentum catapulted car and driver into the air and flipped them 180 degrees, gravity reintroduced them to Earth, and the car was creatively reinterpreted as a smoking pile of twisted slag. Somehow, neither Gugelmin nor any of the other 25 drivers were injured. Demonstrating either heroic courage or evidence of a detached cerebral cortex, Gugelmin went on to compete in his team's spare car and notched the fastest single lap of the race at a more-blistering-than-it-sounds 118.3 mph.

"I will crush you like an egg under a semi, and you will beg for more."

"Let's go home, Ma—them fireworks ain't poppin' for shit."

REECE'S TWO-PIECES

Need motivation to work out? Take a look at a possible prize.

Name: Gabrielle Reece
Date of Birth: 1/6/70
Hometown: Marina del Rey, California
Height: 6'3"

#1 claim to fame: Volleyball superstardom, closely followed by her multiple careers as pinup girl, Nike spokesperson, and hostess of various episodes of *MTV Sports*.

Quote: "I'd much rather have the grind than the glamour because the grind is real."

How Gabby maintains her stamina and energy: By eating four to five meals a day, supplemented with vitamins.

Most appropriate award: Named the nation's Most Inspiring Collegiate Athlete by the Dodge National Athletic Awards Committee when she was a junior at Florida State in 1990.

Further evidence of Gabby's renaissance womanhood: She has written for *Elle* and *Women's Sports and Fitness*.

Least demanding film role: Gabby appeared as a trainer in the 1997 film *Gattaca*.

FIRE FLIES

The neato red thingies are tracer bullets from machine-gun cross fire. It's life inside a video game—now with extra-real death!

Isn't it nice when enemies settle their differences by exchanging gifts? The nighttime volleys of tracer bullets seen here were traded between Turkish police and Kurdish nationalists in Cizre, Turkey, in 1993. Such friendly demonstrations of solidarity between the two groups are still regularly held to this day. What's all the fuss about anyhow? Seems the Kurds, who claim they descend from Noah (um...but we all do, right?), have been trying to carve themselves a prime hank of homeland for centuries. Our own Woodrow Wilson promised 'em one in 1918 but, as usual, couldn't convince any Europeans to go along with his scheme. And so, the 20 million Kurds who now exist are scattered across Turkey, Iraq, Iran, Syria, and various unpronounceable ex-Soviet republics. The Kurds' odds of becoming unified in the near future? We reckon they're about the same as Humpty Dumpty's.

My Pretty Pony comes with leg splint and pistol; other ponies sold separately

ALL FALL DOWN

Leave it to the Italians to combine horse racing with demolition derby.

If you're going to be a jockey at the Palio, Siena's annual civic horse race, you'd better carry a big willy—literally. In this 800-year-old anarchic free-for-all riders whip their opponents with stretched, dried bulls' penises. Come again? The Goodwill Games it ain't: Deliberately interfering with other horses is considered perfectly kosher, and bribery and secret alliances between cliques of riders is the rule, rather than the exception. It seems that the race is a sort of institutionalized form of urban tribalism, which allows the different *contrada* (the close-knit districts that make up the city) to work out their mutual hostility in a ritualized, socially acceptable way. And hey, if a few horses get turned into cat food and some jockeys wind up with prosthetic legs and heads, isn't that a small price to pay for 364 days of peace and quiet?

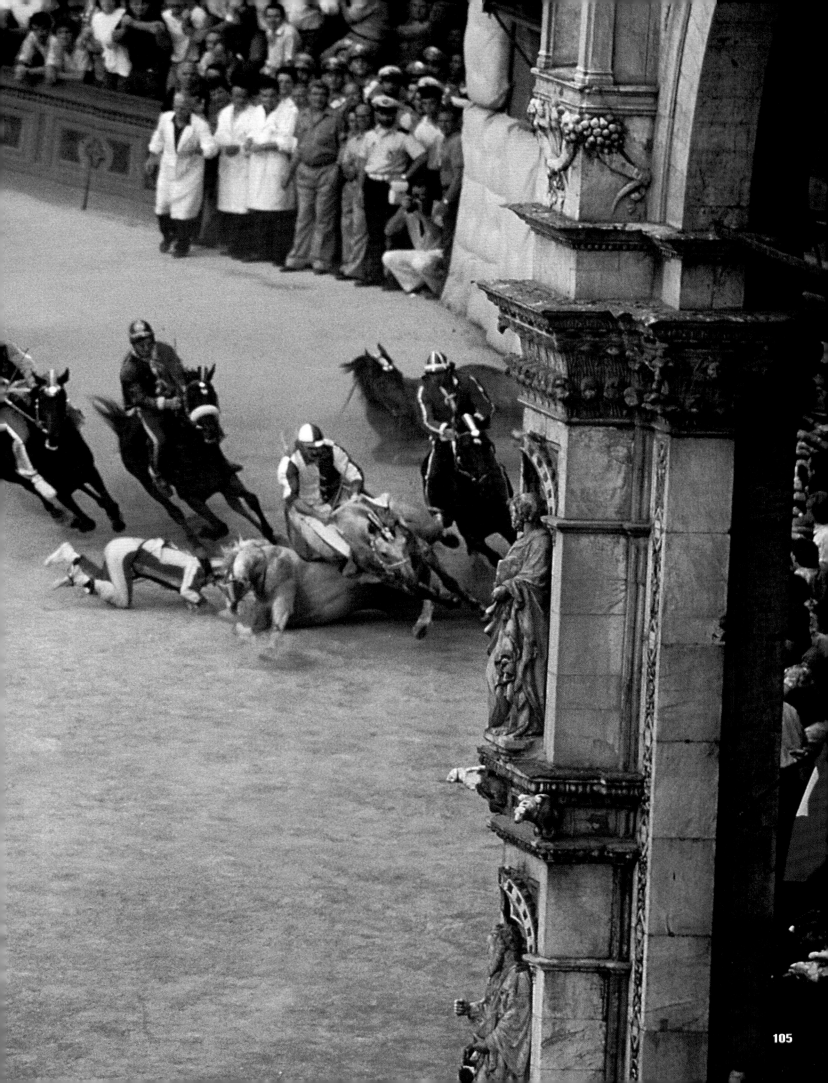

An unspoiled Eden of breathtaking natural beauty. Call in the strip miners...

ISLE OF LIGHT

Behold the fjords of southwestern New Zealand: A subequatorial paradise so beautiful, it justifies living upside down.

First discovered by Captain Cook just over 200 years ago, Dusky Sound, the pristine vista illuminated here, boasts many New Zealand firsts. Here you'll find the island's first European house, first European settlement, first European-built ship...even the first Kiwi beer was brewed here. (And is it getting skanky after two centuries.) For all its history, the South Island bay, now a refuge for native birds like the kakapo, is one of the most uninhabited parts of the mainland, "the only place in New Zealand completely unchanged by time since Cook's landing," according to the photographer. Nothing a few hundred condos and a Hard Rock Cafe couldn't fix.

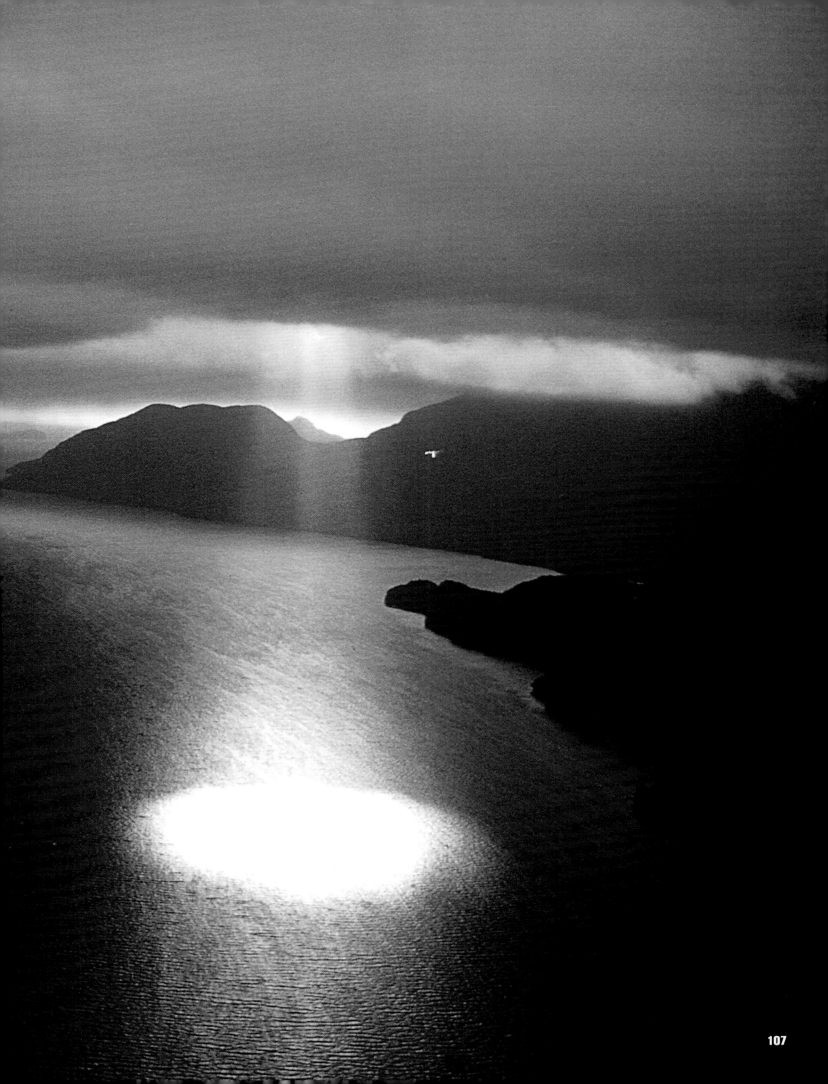

"This little piggy went to market. This little piggy stayed home. The end."

"HONEY, FOOT ME THAT BEER, WOULDJA?"

Members of the unfortunate Wadomo tribe prepare for another harrowing day of shoe shopping.

The condition you see here is extremely rare, unless you happen to be a member of the Wadomo tribe of Zimbabwe. According to tribal lore, it originated when an outside female joined the tribe and gave birth to a two-toed child. Showing a distinct lack of sensitivity toward freakish, cockroachy, bad-acid-trip-nightmare deformities, the tribe put the sock-challenged squirt to death and did the same when she pumped out Pincer Boy #2. When number three arrived, however, the tribe thought it must be the will of God, and they let him live. The two-toed gene spread, and more and more such children were born into the tribe. The head of this family is 36-year old Bembe Mkuhlana, a one-man sideshow who also sports webbed fingers, a hand with two thumbs, and another hand missing three fingers. Oh, and in his boxer shorts? We don't know. We were too terrified to look.

TOUR DE HELL

This fatal accident provided a convincing argument for making helmets mandatory at the Tour de France.

When American cyclist Lance Armstrong pointed to the sky and blew kisses upward just before winning the last stage of the Tour de France in 1995, he wasn't thanking God for his victory. He was paying tribute to Fabio Casartelli, his 24-year-old Motorola teammate who had died a few days earlier after a high-speed crash on a mountain pass in the Pyrenees. At speeds approaching 55 mph, a pack of riders failed to negotiate a steep curve while descending the pass and wiped out en masse. Armstrong's ill-fated Italian teammate, who wasn't wearing a helmet, slammed into a concrete block on the side of the road and fell heavily onto the pavement. He went into a deep and immediate coma, and never came around. Before the start of the 16th stage the next day, a minute of silence was held for Casartelli, just the third fatality in nearly a century of Tours.

Studies once again confirm sitting on a couch is safer than biking without a helmet

DRY HUMPING

Think your county's had a dry spell? In sandblasted, rain-free, godforsaken North Africa, this is a lake.

With newly erupted volcanoes, summer temperatures topping 120 degrees, and Ethiopia only a hop, skip, and a jump away, the salt flats of Djibouti's Lake Assal are attracting vacationers like...well, like Beirut in Uzi season. Featuring the lowest point in all of Africa, geographically (500 feet below sea level) as well as inspirationally, the northwest half of the "lake" is dry most of the year. Sure, fishing's a little tough, but if you're looking for a summer job, you're in luck. Here, Ethiopian merchants cut salt blocks in the scorching white heat, load them onto camels, and transport them to the nearest so-called towns for sale, and they're always looking for dumb animal labor like yourself. Get a good saddle, though: The sandstorm-swept, boulder-strewn track can be rough on the nut cluster. Oh, and watch your step—the lava seeping from the active volcano along the Eastern shore will give you a hotfoot right to the bone. Suddenly, slinging pizza at the mall sounds like a workers' paradise.

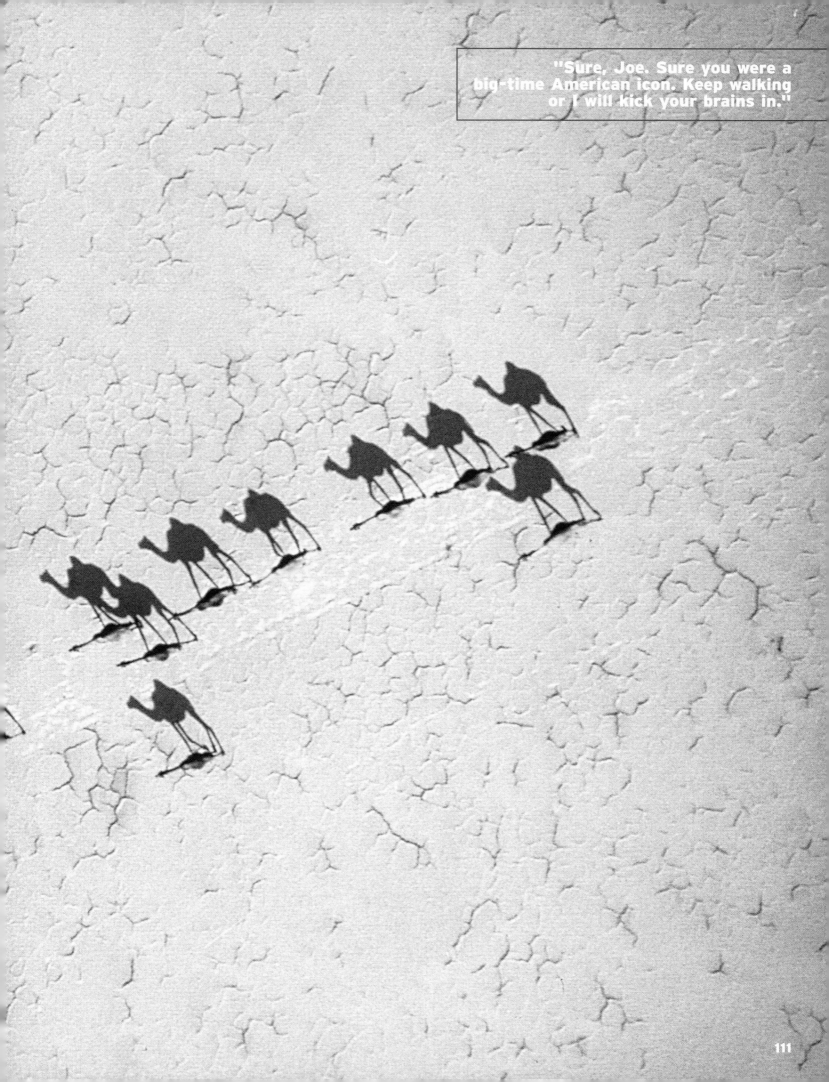

Rectum? Damn near killed 'im!

HOLE **IN JUAN!**

Caution: Waving red flag at angry bull may result in one seriously tender loaf-pincher.

Perhaps a good conflict-resolution specialist could have helped resolve this 1997 incident at Bogotá's Plaza de Santamaria Stadium in a less hurtful way. Granted, the spear in his back may justify our bull's unreasonable and unfriendly attitude, but we still must frown at him for allowing hostility to get the better of him and dictate his actions. Here we see the results of such a loss of self-control. Two days after the goring, bandillero Manolo Beltran was listed in "guarded condition" at a nearby hospital with severe, ah, *internal* injuries. If it's any consolation to the poor guy, his example will remind the rest of us of an invaluable lesson: When a psychotic 2,000-pound beast is sprinting toward you with horns a-tiltin', get your ass out of the way.

SEAR SUCKER

What's found in lakes, creeks, and puddles worldwide, drinks blood, and sucks more emphatically than the Backstreet Boys?

We're referring, of course, to leeches. Fortunately, unlike their IRS counterparts, a hot flame to the ass is all it takes to get 'em off your back; and the faster you torch 'em, the lower the risk of infection. Though leeches have famously been useful in medicine to drain blood from wounds and infected areas, we still feel more revulsion than gratitude. This historical anecdote may help explain why. In 1799, Napoleon's soldiers were marching to Syria through the desert; iced café au lait being in short supply, they drank whatever water they came across, including leech-infested water that proved to be their undoing. Happily attaching themselves to the insides of noses, mouths, and throats, the little suckers feasted on the soldiers' wine-and-farty-cheese-enriched blood. As their tiny bodies swelled, they started blocking off the French dudes' air passages, and hundreds died from suffocation and/or excessive blood loss. A grim tale...and proof positive that the French will, indeed, eat anything.

KLUM AGAIN?

We weren't going to run more than one picture of any individual girl, but after seeing this photo, what choice did we have?

When asked about the 20-year-old, pre-superstar Heidi Klum, seen here in the first corset she ever squeezed into, photographer Phillip Wong recalled his subject as totally comfortable with nudity and a joy to work with." Easygoing, self-effacing–she enjoys life and where she's at," he said, in a faraway voice. The agency she was with at the time, on the other hand, was less than enthusiastic about the shoot. Showing foresight on a par with the coach who cut a young Michael Jordan from the high school basketball team, Wong explains that the brain surgeons there had her pegged as a "JCPenney-level catalog model." D'oh! They never dreamed sex goddess status would follow for Heidi (*drum roll*)...but of corset did! (*cymbal crash*)

"But ma'am, 'No shoes no service' is only part of the rule"

SURFIN' TURF

How do you persuade all dirty capitalists to keep the hell out of your blighted desert homeland? Hang ten.

Sandboarding, a bastard hybrid of skateboarding, surfing, and snowboarding, can drop luckless barneys down the sheer face of a dune in excess of 50 mph. As demonstrated by this Qatari guide, who organizes sandboarding tours in the desert for curious tourists, this may look like the wacky extreme sport du jour. But sandboarding has been around—in a primitive form, anyhow—since the time of the ancient Egyptians, who used to take a break from piling up blocks of stone and worshiping cats to slide down the dunes on planks of hardened pottery and wood. Today, a thriving international subculture of sandboarders exists, as illustrated by the 50,000 people who attend the annual championships in Germany, a country that makes up for its marked sandlessness with a long tradition of extending a warm "fist of welcome" to all strangers, regardless of race, creed, or genetic unfeasibility.

TOP OF THE WHIRL

High up in the frapposphere, the gods whip up a tasty blender drink for a thirsty planet.

Is this a lost tornado, tragically separated from its trailer-park host? A John Goodman fart grown into some monstrous city-razing vortex? Nope, though the latter raises interesting film possibilities. This here's just a cloud, hovering above Mt. Rainier, looking pretty and minding its own business. An Altocumulus Stacked Lenticular Cloud, to be exact, not that this means anything more to you than it does to us. But according to the scrub intern we tricked into looking it up, they occur near mountain ranges, and stand still in one spot as air passes though them. Kind of like John Goodman, come to think of it.

HIGH STRUNG

The shortest distance between two points is a straight line—or a straight plummet, depending on your balance.

There's a certain undeniable thrill to reproducing your butt on the office photocopier and, uh, "flavoring" your boss' coffee, but neither is exactly a cardiac inducer. Why? Because nothing pumps up your adrenaline like the risk of immediate painful death. So next time you're bored, grab a rope, update your will, and head on over to Smith Rock State Park in Oregon, where you can walk, like Adam Grosowsky here, across a chasm on a tightrope, hanging ass several hundred feet above the trail below. True, the slightest stumble and you'll literally dig your own grave, but at least you'll get to spend your final moments admiring the gorgeous kaleidoscope of cliff walls and majestic, rugged trail rushing up to greet you as you accelerate at the rate of 32 feet per second. What more could a man ask for, outside of a parachute?

"For God's sake, officer, I swear
I only had two beers!"

"Master, Little Feather's contemplating my navel again."

TERIYAKI STRIPS

Never have more people tried harder not to get an erection.

Some cultures see the winter as a time for quiet introspection, a searching of the soul through long, dark nights. To the Japanese, winter's about getting ripped on sake and running naked through the streets. Every February, thousands of small but hardy men strip down to embarrassing cotton G-strings called *fundoshi* and stuff themselves into Shinto shrines such as this one, the Saidai Temple in Okayama City. (*O-o-o-o-o-kayama! Where the wind comes sweeping...*ah, forget it.) Why? To await the appearance of the *shinotoko*, the completely nude god-man whose big entrance (laser lights, "Are you ready to rumble?") ignites a nudie riot as throngs of middle-aged Japanese men vie to touch him and thereby achieve self-purification. The notion that self-purification can be achieved by touching a naked man is just one of the many inscrutable gaps between Japanese and Western culture (see also Sushi, Sumo, and Respect for Elders).

DAIRY QUEER

In Queensland, Australia, the Pioneer Farm's freak cows really have a leg up on the competition.

Maybe you're aware that cows have four stomachs, but we betcha didn't know they *don't* have four legs. Not at Craig Melville and Jesse Brunskill's farm in Queensland, Australia, anyhow. Folks from many miles away flock here to get a gander at five-legged cows, like Rolf here and, for the kiddies, Hop-Along, the three-legged calf. The mootants are real; each of the five-leggers sports a fifth limb on her back, which dangles toward the ground uselessly. (Editor: Insert generic Bob Dole joke.) Some local yokels think the mutations might result from eating chemically contaminated grass; others suggest the cows are really top-secret military robot cows with supercomputer megabrains, programmed to destroy all other life-forms on the planet. Nope—just cows, says Brunskill. "They are good animals, and people like to look at them when they visit the farm." Sure, pal.

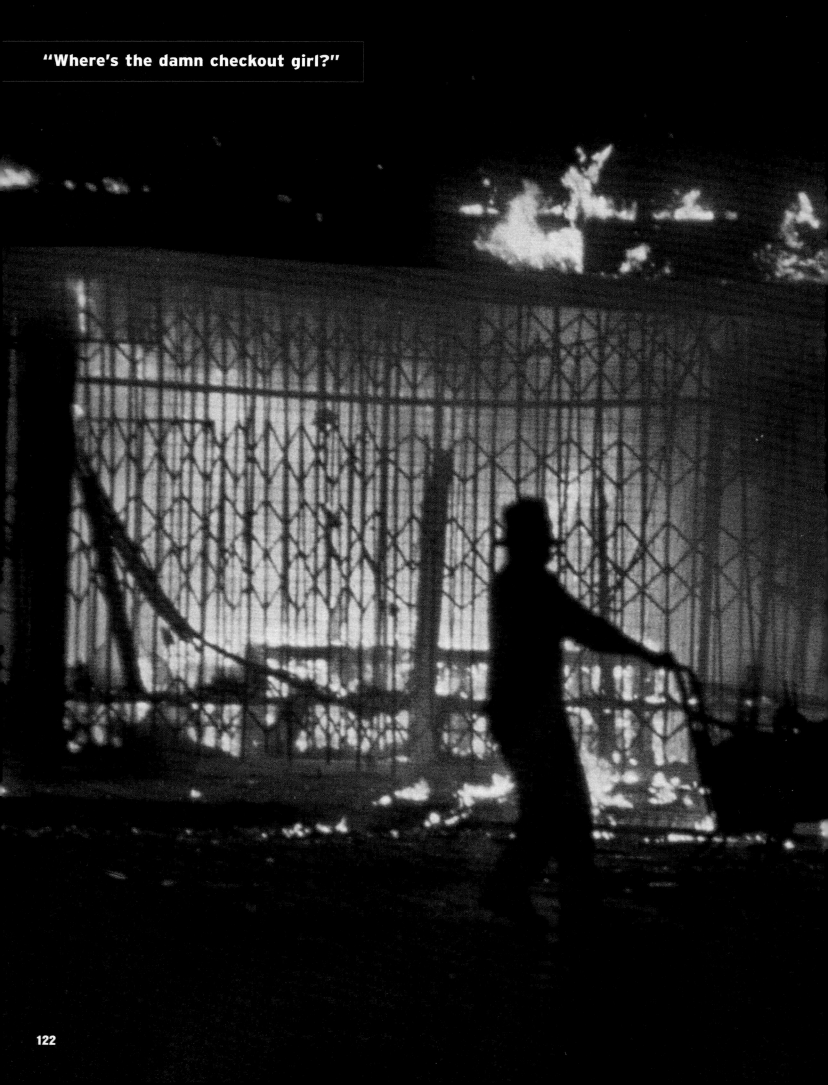

"Where's the damn checkout girl?"

100%-OFF SALE!

Some people get all fired up about holiday shopping.

To some people in South Central Los Angeles, the horrific 1992 riots there meant one thing and one thing only: Free stuff! People like this guy, who was lucky enough to pull an ultra-valuable grocery cart from the flaming carnage, carted off all manner of merchandise. Ground zero for the looting rampage was Tom's Liquor and Deli. There, a group of citizens, morally outraged over the verdict that acquitted the cops in the Rodney King case, decided to take matters into their own hands and score free hooch. Other crusaders soon took up the cause, and by the time the civic disobedience in the name of justice (and low, low prices) had ended, 3,100 businesses were devastated. Anonymous tips led police to some of the merchandise, as did live television coverage of the riots that caught boneheads in the act. But the understandably upset owner of Tom's Liquor told reporters that their coverage was like an ad saying, "Hey! Free beer!" Hey, lighten up: Rioting is thirsty work!

"Well, yes, there's that. But it's in a nice neighborhood, close to schools."

HOUSE HOLED

Isn't it a drag when the ground opens up and your house, car, and possessions are sucked into the bowels of the earth?

In one sense, home owners in Frostproof, Florida, are lucky. As their town name suggests, freezing weather rarely wrecks their houses. They also don't have tornadoes, earthquakes, sandstorms, or giant man-eating lizards. What they do have are sinkholes, such as the one pictured here, and lots of 'em. In 1981, the Great Winter Park Sinkhole, a 300-by 100-foot monster, swallowed up a number of parked cars, a house, several trees, and most of a municipal swimming pool, leaving the itty-bitty city quite literally $2 million in the hole. Among your more peculiar natural disasters, sinkholes are topographical depressions (that's fancy-pants for "pits") that most often form when water meets soluble limestone bedrock underground, dissolving it and leaving a vacuum for the earth above to collapse into like a rack of cheeseburgers tumbling into Rush Limbaugh's gaping maw. If your property happens to be on that land, it's time to pour yourself a stiff drink and check the fine print on your insurance policy to find out just how sunk you really are.

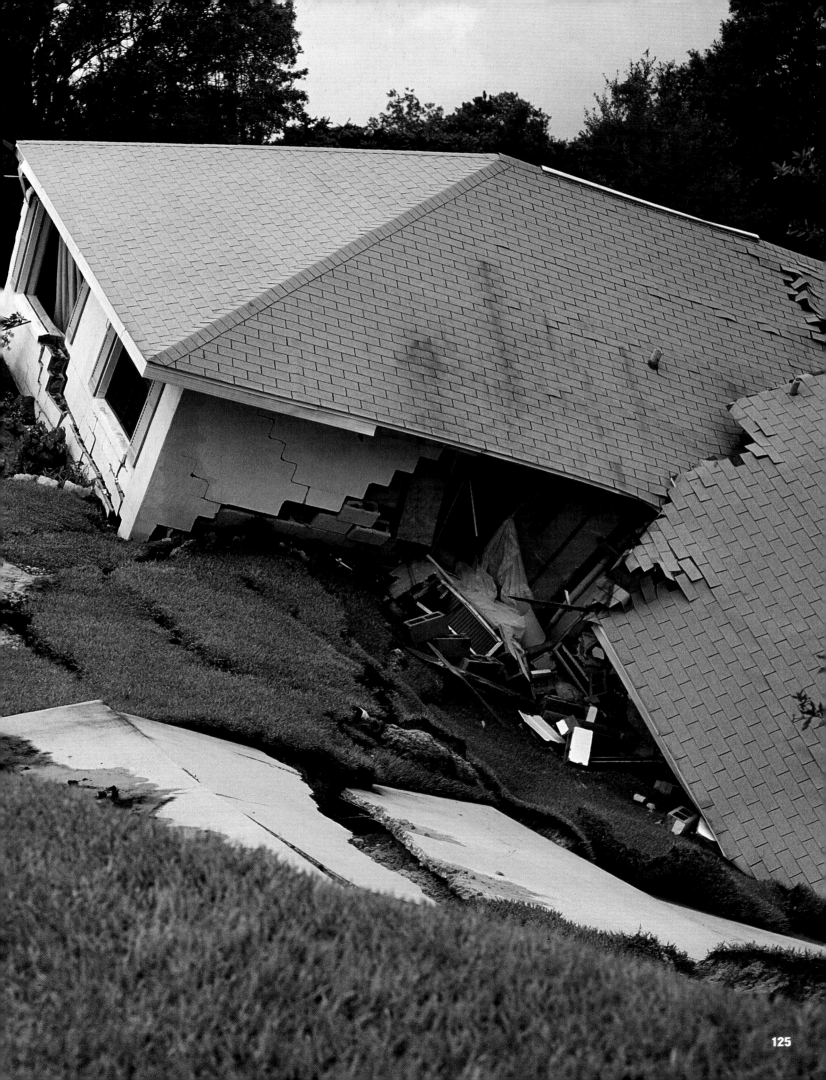

Patented twin-blade action soothes your skin

OH, SHIITE!

All religions mourn their martyrs...some more dramatically than others.

Imagine if every Easter, instead of hiding colored eggs and avoiding church, your religion required you to drive nails into your wrists and ankles, and parade through the streets, bleeding and chanting, "Jesus Rocks!" It'd be the rough equivalent of what Shiite Muslims in the Middle East and Pakistan do during *Ashura*. This 10-day holiday commemorates the 680 A.D. slaying of the martyr Hussein (not the one you're thinking of), a feller whom the Shiites believe to be the Prophet Mohammad's grandson. Fervid mourners, in a gesture of self-denial and adoration, slash their own heads and flay their backs with bladed chains. Known as *qameh-zani*, the self-mutilation is so gruesome that even the Ayatollah "I Chop Arms off for Jaywalking" Khomeini condemned it as "senseless and superstitious." Still, experts concur it beats dating Sandra Bernhard.

NASAL DESTROYER

Another reminder to never go through coke rehab in China.

Need further convincing that the moon makes people behave strangely? Consider this photo taken at Beijing's Longtan Lake Fair, the exciting annual spring festival at which average Chinese citizens shed the horrible drudgery of their everyday lives by celebrating the start of the lunar new year. It seems that the best way to celebrate this occasion is by publicly inflicting incredibly intense pain on yourself in ways that would make Ozzy Osbourne recoil in disgust. This Chinese man, presumably motivated by a desire to one-up Letterman by simultaneously performing a stupid human trick and a stupid pet trick, fed a live snake into his nostril and out his mouth during a performance at the fair on January 27, 1998. No word on how many members of the audience tossed cookies.

"Winner, Best Marketing Campaign: Bob's Chain Link Fences, Inc."

A PINT OF AMBER

Curl up with a tall, cool glass of refreshing pinup girl.

Name: Amber Smith
Date of Birth: 3/2/72
Hometown: Tampa, Florida
Height: 5'10"

#1 claim to fame: Take your pick: acting (*Private Parts*, *American Beauty*), brightening the walls of countless college dorms with her millennium pinup calendar, or pioneering her own Web site (www.ambersmith.net).

Quote: "A woman might as well put up a little fight. You know, make the guy work for it. At least for a little while."

On her lucky black panties: "They have a teeny lace patch in the front—from far away it looks like pubic hair, and I think that's hot. I've had some good times in them."

Fitness secret: "I have a lot of anxiety and, honestly, it just melts off through worry. I'm a very nervous person. And that's my trick!"

Refreshing view on nudity: "I posed for *Playboy* because I felt like it. This quote-unquote 'it's artistic statement' is just an excuse, really."

PORK IN THE ROAD

A routine trip to the sausage factory turns into a hogocaust.

Holy sides of bacon, Batman! This photo shows the aftermath of an April 17, 1998, accident in which a truck transporting 200 pigs overturned on the Tauern highway in eastern Austria. The driver survived with only a couple of sore hams, but many of his porky passengers died in the accident, their young lives tragically snuffed out before they could fulfill their destinies of being herded into one-way pens, slaughtered, gutted, etc. Survivors, realizing it could have been wurst, seized the opportunity and tried to waddle out of Dodge; some even made it dozens of feet toward freedom before being patiently herded back so they could be killed and devoured as God intended. In an ironic twist, on the very day of the accident, a German price and market reporting agency announced that European pig supplies would increase by an estimated five percent for the year. Maybe, but as these little piggies went to market, pork-belly futures looked none too bright.

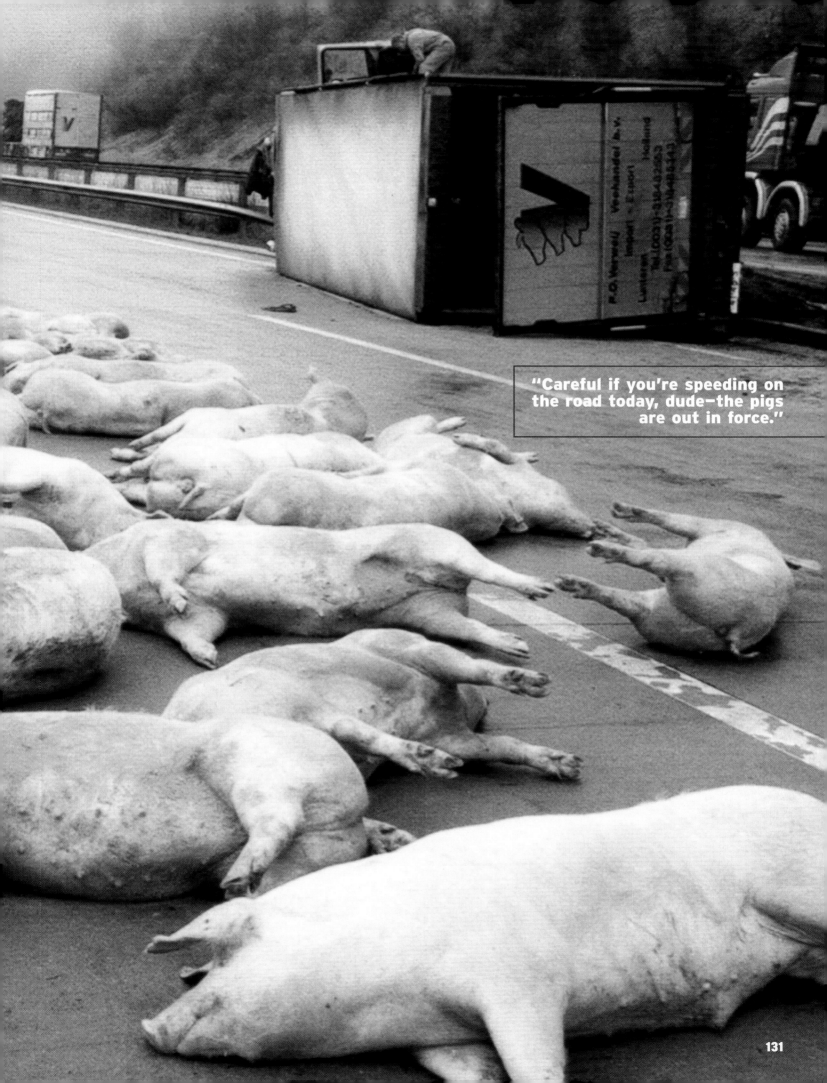

"Careful if you're speeding on the road today, dude—the pigs are out in force."

Dude, you seen the new sexbots from Planet Zorgon-11?

THANK YOU PA'AM

Jaw-dropping babe, queen of *Baywatch*, and low-fat, non-stick butter substitute—we love you, Pam.

Name: Pamela Anderson Lee

Date of birth: 7/1/67

Hometown: Ladysmith, British Columbia, Canada

Height: 5'5"

#1 claim to fame: Her role as CJ on *Baywatch*...and her role as Vallery Irons on *V.I.P.*...and her record number of *Playboy* covers...and her costarring role in the best-selling amateur porn video of all time...and...

Quote: "Believe it or not, I'm not obsessive about my own body."

Rumored contribution to the community chest: Unconfirmed reports indicate that Pamela may auction the silicone bags from her breast-reduction surgery on eBay and give the proceeds to charity.

On that shrinkage: "It's something I've been wanting to do for a long time, and I'm very happy with my decision."

Worst pick-up line she's ever heard: "My bologna has a first name—it's L-A-R-G-E."

UNAUTHORIZED

WHETHER YOU DECIDE TO SEND IT BACK IN 21 DAYS . . . OR KEEP IT FOREVER . . . YOUR SATISFACTION IS 100% GUARANTEED!

The latest book from *Maxim* is SO hot that IT SHOULD BE ILLEGAL! Packed with scorching photos that are too hot for the magazine!

You won't believe it 'till you see it! So act now and order it free TODAY!

If you decide to send it back, your satisfaction is guaranteed because you pay absolutely nothing. Nothing to send for the book. Nothing for the privilege of looking at it. Plus, you get a free gift for your trouble!

You will learn enough secrets in this book to have a completely unfair advantage over women!

Maxim gives you:
- A FREE trial period
- A money back guarantee
- A FREE gift
- And one of the hottest books on the market!

Plus a FREE GIFT!

99 Maneuvers To Make Her Moan
By the editors of MAXIM

MAXIM
BOOKS

Call Toll-Free, Operator AB1 right now!

Call 1-877-212-1937

All this for only $19.95 plus shipping and handling! Order now!

PAY FOR IT ONLY IF YOU WANT TO KEEP IT LONGER!

Isn't technology great?

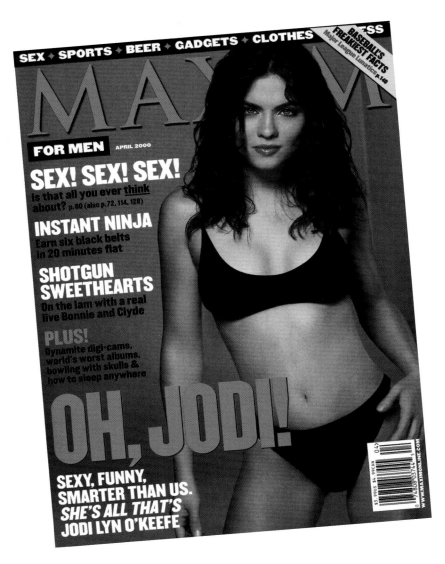

The cover of MAXIM magazine, April 2000 issue, featuring:

SEX • SPORTS • BEER • GADGETS • CLOTHES

BASEBALL'S FREAKIEST FACTS
Major League Lunatics p.140

MAXIM

FOR MEN — APRIL 2000

SEX! SEX! SEX!
Is that all you ever think about? p.80 (also p.72, 114, 128)

INSTANT NINJA
Earn six black belts in 20 minutes flat

SHOTGUN SWEETHEARTS
On the lam with a real live Bonnie and Clyde

PLUS!
Dynamite digi-cams, world's worst albums, bowling with skulls & how to sleep anywhere

OH, JODI!

SEXY, FUNNY, SMARTER THAN US. SHE'S ALL THAT'S JODI LYN O'KEEFE

Relax. It's Maxim.

Did you ever get the feeling with some magazines that you have to sit up straight when you read them? Whatever you do, it's just not enough for them. You're lacking something.

That other magazine doesn't really love you. They think they'll be able to change you. They'll get you to throw away your favorite shirt, redecorate your home, and start drinking Kirs, for heck's sake.

And then that other magazine will start complaining about how you've changed and things just aren't the same as when

you met. And you'll say it's the other magazine's fault, that they don't care about you and never want to listen to what you have to say. And that they look fat.

Nobody needs that kind of heartbreak.

At *Maxim* you're among friends. You don't need an attitude; you don't need a complex.

And heck, if you subscribe you don't even need pants. Just call the toll-free number below and each monthly issue will be mailed to your door.

Continue those day-trading conquests while your new girlfriend, a recent Miss Brazil, fixes you both a tasty snack. Eat hearty: You'll need all your strength for the night ahead. Crack open a cold one, imported or domestic —we're not about to force some obscure Basque pond water down your throat. And while you luxuriate in your pleasure dome, a snappily dressed agent of the United States government will do all the legwork.

Now see if you can get him to swing by with a carton of Luckys and you're all set.